WINCHESTER
THROUGH TIME
Anne-Louise Barton

AMBERLEY

Acknowledgements

I am most grateful to the following people for allowing me to use postcards from their collections: David Fry, Steve and Jenny Jarvis, Graham MacKay, Edward Roberts and Sandra Roll. The photograph of Chesil Railway is credited to John Thorn. Several photographs are from the Derek Dine Collection (70A09), held at the Hampshire Records Office. Further images are reproduced from original Francis Frith postcards by permission of the Francis Frith Collection. Last but not least I thank my father, John Barton, not only for the use of his postcards, but most importantly his invaluable editorial assistance and local knowledge.

First published 2013

Amberley Publishing
The Hill, Stroud, Gloucestershire, GL5 4EP
www.amberley-books.com

Copyright © Anne-Louise Barton, 2013

The right of Anne-Louise Barton to be identified as the Author of this work has been asserted in accordance with the Copyrights, Designs and Patents Act 1988.

ISBN 978 1 4456 1273 7 (print)
ISBN 978 1 4456 1296 6 (ebook)

British Library Cataloguing in Publication Data.
A catalogue record for this book is available from the British Library.

Typesetting by Amberley Publishing.
Printed in Great Britain.

Introduction

Living in a city for many years, walking along the same streets and passing familiar buildings, it is easy to forget just how much history surrounds us. I have often envied visitors their time here in Winchester, and thought how satisfying it would be to see and photograph things for the first time. Compiling this book has enabled me to re-immerse myself in Winchester's history and in doing so, I have discovered new facts and the odd pathway I never knew existed.

Changes in the past forty years include those that have benefited the shopper, such as the pedestrianisation of the High Street and the excavation of the Brooks area prior to building a new shopping centre. Property developers continue to snap up land and build prestigious houses and apartments, but there has also been housing for an increasing student population such as Erasmus Park and West Downs Village, and new blocks of accommodation and amenities are currently being built behind the County Hospital. Education and students have become important contributors to the city's prosperity and also its cultural life.

Despite the Twyford Down protests the M3 motorway extension went ahead, finally opening in 1995, although traffic had already bypassed the city since 1938. Traffic in the city, however, was on the increase and the 1950s and 1960s saw many buildings pulled down to make way for wider streets and car parks. Industrial businesses were encouraged to move to trading estates just outside the city centre. Post-war demands for housing resulted in many developments appearing around the city; the first phase of Stanmore was built in the early 1920s.

Winchester escaped damage from the World Wars, with only one incident of bombs falling at the southern end of Hyde Street. The barracks could not house all the recruits that came forward in the Second World War and Bushfield Camp was established, two miles to the south. During the First World War troops camped to the east of Winchester in an area stretching from Morn Hill to Avington Park. The close proximity of the Newbury, Didcot and Southampton railway line that had opened in 1891 was to benefit the camp.

The second half of the nineteenth century saw hotels, inns and businesses flourish following the arrival of the railway; Winchester station opened in 1839 following the completion of the line from Southampton. Trains ran from London to Basingstoke and a year later the section between Basingstoke and Winchester was complete, linking the capital with the South Coast. Winchester had plenty to offer both residents and visitors, and day trippers were now able to make the journey. The population had already increased as more efficient agricultural methods

drove workers from the countryside to the city. In the 1841 census it was recorded at 10,732 and by 1881 it was around 19,000. Residential areas spread outwards, with large private properties reflecting a prosperous Victorian society. To the south the village of St Cross was absorbed, and to the north the village of Weeke.

In 1875 a new pumping station opened in Garnier Road, which overcame the problems of sewage disposal that had plagued the city for years. Winchester became healthier, hotels advertised 'modern sanitation' and the chemist Hunt & Co., then at No. 45 High Street, advertised 'High-class mineral waters and foreign mineral waters.' Photography was an exciting commercial venture and several photographers worked from studios in the city. Guidebooks were illustrated with photographs for the first time and postcards were sent all over the country and abroad, giving people the chance to show Winchester to family and friends for the first time.

Winchester's history of course goes back much further, but it is the past 120 years or so that is focused on through these postcards and photographs, showing us the changes that have taken place. There were many more images that I wanted to use, and it was with much reluctance that I couldn't include them all, but I hope this selection gives a satisfying overview of Winchester through time.

I have grouped the images roughly in the following order: streets (in alphabetical order), the High Street (from top to bottom), buildings, military and transport interest, open spaces and waterways, and finally a few outlying villages.

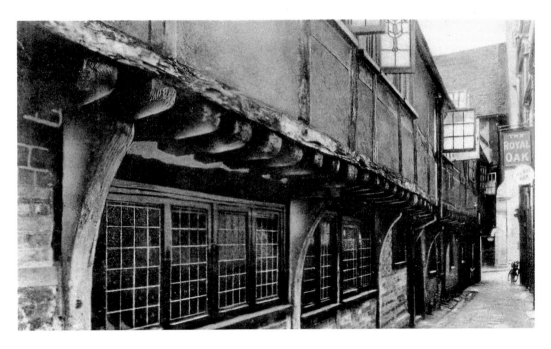

Alwarene Street

Between 1160 and 1290 a Jewish community was established in Winchester and the eastern boundary was the old Alwarene Street, the passageway that now runs between the God Begot House and the Royal Oak pub. The pub was built in 1630, and became known by its name soon after the Civil War, and this cobbled alleyway is now known as the Royal Oak Passage.

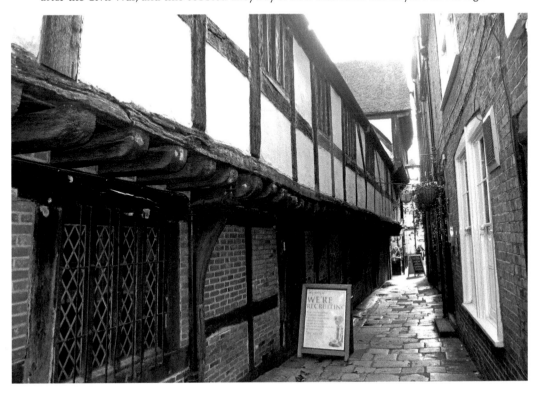

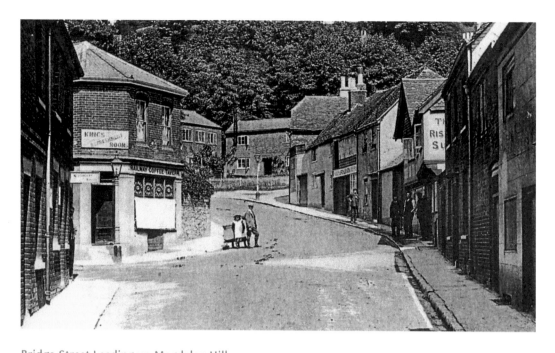

Bridge Street Leading up Magdalen Hill

On the left corner stood the Railway Coffee Tavern, serving passengers alighting from the nearby Chesil station when it opened in 1885. The houses on the right have been replaced by buildings set back from the road. St John's Street on the left was the main road to the east before Magdalen Hill superseded it.

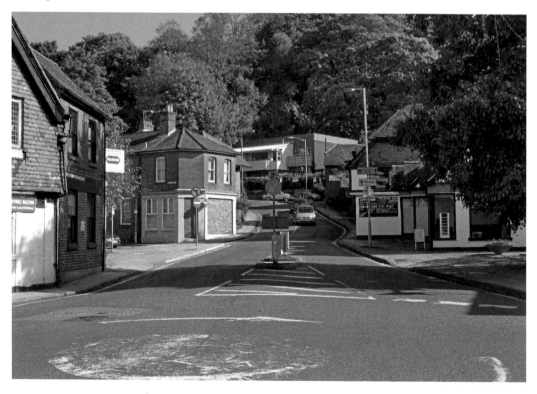

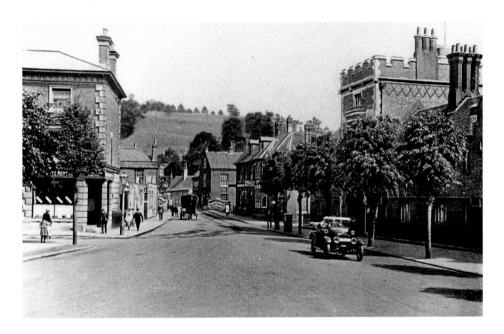

Bridge Street from Broadway

A typical street scene of around 1930 with both horse vehicle and motor car. The Great Western Hotel on the right was built in 1892, seven years after the Didcot, Newbury and Southampton railway line opened. The signs advertise 'cars for hire' and 'billiards'. After many name changes, this is now the Bishop on the Bridge (named after St Swithun). On the left is the Eastgate Restaurant which opened in 1926. There is now a row of shops between this building and the bridge.

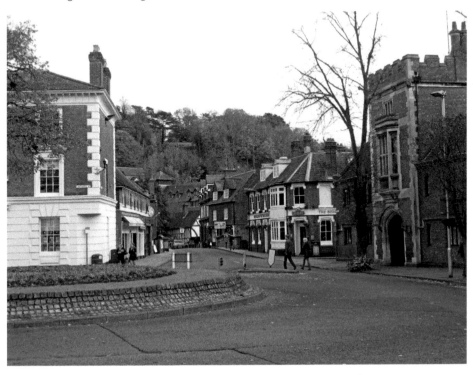

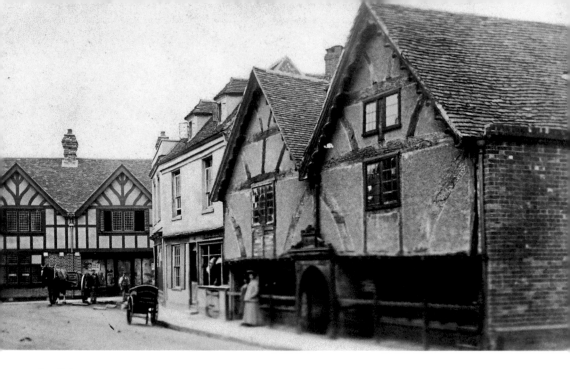

Chesil Street

Two shops once stood at the end of Chesil Street, but they were pulled down for the benefit of an early street-widening scheme. The Chesil Rectory was built by a wealthy merchant around 1450. Half-timbered, it is a remarkable survival of medieval Winchester when very few buildings were built of stone. It was restored in 1892 to 1893, and has been a tannery, antiques shop, tea room, general store and for the past fifty years, a restaurant.

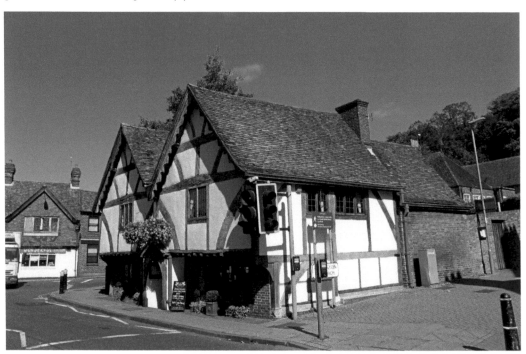

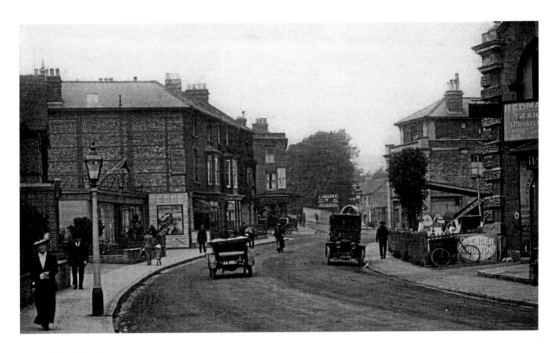

City Road

The Oriel Temperance Hotel stands on the left here in 1916. On the right is a disused chapel and the taxi company Redman & Co. This road has seen much development, particularly in the last five years. The area was once well equipped for car maintenance services, with Kwik Fit on one side and a garage workshop on the other. Now there are new apartment blocks on both sides, and a conveniently situated Co-operative store that opened in 2012.

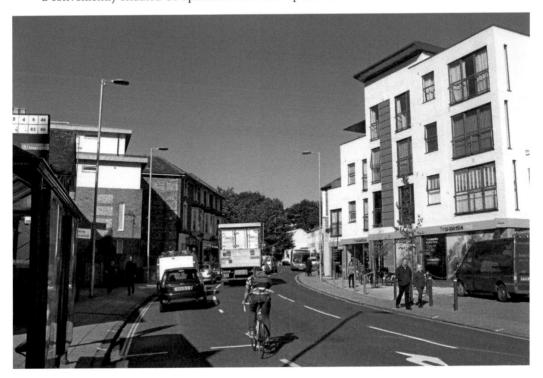

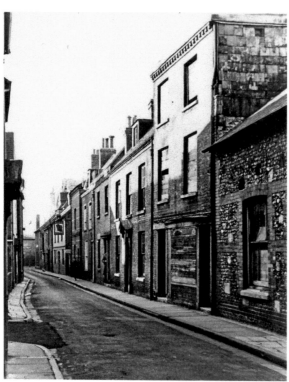

Colebrook Street

This street including the Royal Standard pub (whose sign you can see towards the end of it) was demolished in the early 1960s when the City Council approved plans for a new hotel. Parliamentary sanction was required as it was to be built on an ancient burial ground. The Wessex Hotel opened in 1964; its actual address is Paternoster Row which passes underneath it. The name 'Amen Court' in the forecourt refers to 'Amen Passage', a lane that ran alongside the pub.

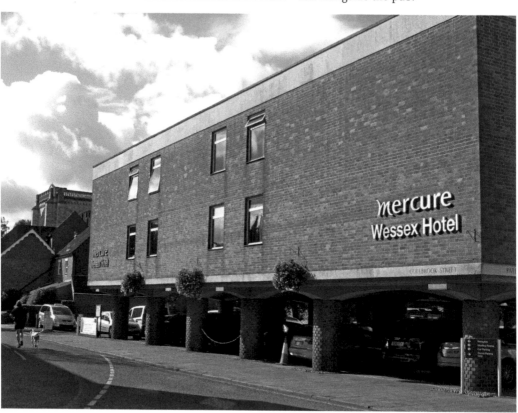

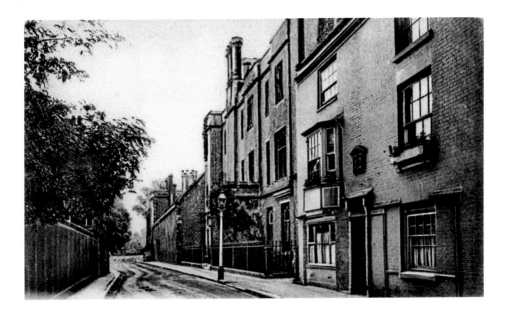

College Street

A destination for the literary tourist. In 1817, for the last few weeks of her life, Jane Austen lived at No. 8 College Street. It was here also that she wrote the poem *Venta* about the people attending the annual Winchester races on St Swithun's day. Sixty years earlier John and Thomas Burdon began trading at No. 11; the earliest recorded receipt for 'stationery, books and binding' to the Bursars of Winchester College was in 1757. The bookshop became P&G Wells in 1891 and continues to serve the college and local community. The bindery still operates from the premises, now as a separate business.

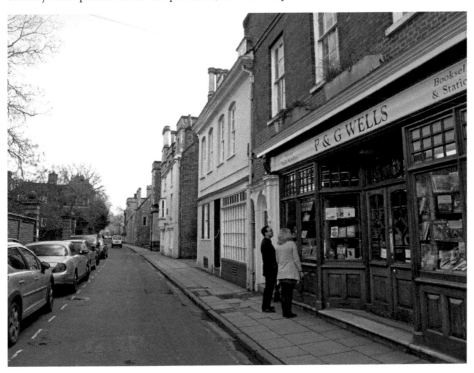

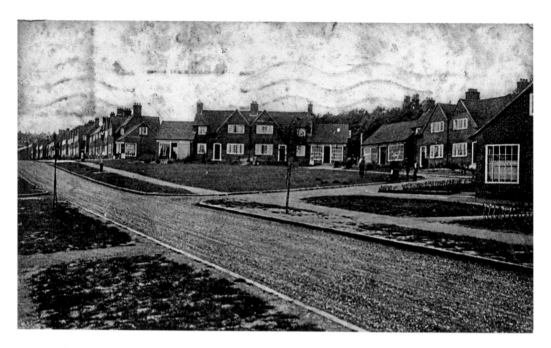

Cromwell Road, Stanmore

After the First World War housing was in short supply and the Government was offering financial aid for housing schemes. The city purchased 100 acres of land between St Cross and Romsey Road, and the 'model estate' of Stanmore – plans of which went on display at the Wembley Exhibition of 1922 – was developed. Work began on 'new Stanmore' in 1946, and a further 624 houses were built.

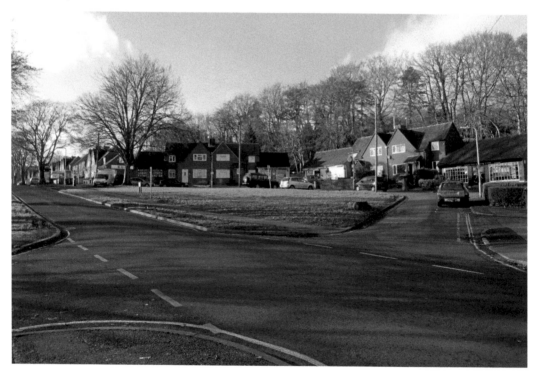

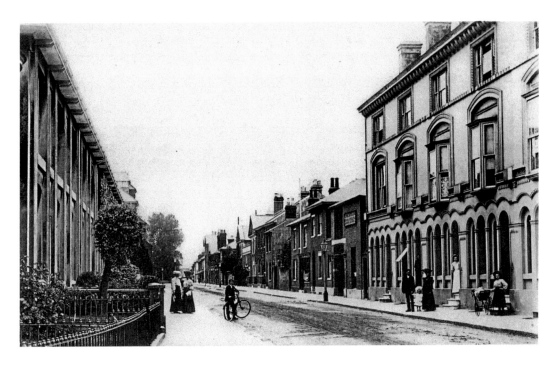

Eastgate Street

Eastgate Street is relatively new in the historical context of Winchester, having been laid out in the middle of the nineteenth century after the demolition of Eastgate House. Also known as Mildmay House, this was a splendid mansion built on the site of the Black Friars monastery. King George III and Queen Charlotte stayed there for several days and were said to have admired the view of St Catherine's Hill. Impressive buildings are still to be seen on the left side of the road, but those opposite have been replaced.

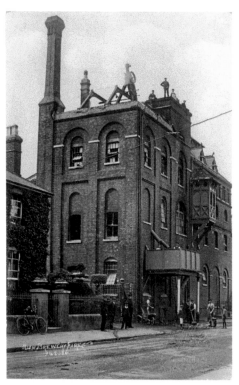

Eastgate Street

The Lion Brewery was one of several breweries operating in Winchester at the beginning of the twentieth century; others could be found in Chesil Street, the corner of Southgate Street and St James's Lane, and Hyde Street. Brewing ceased at the Lion Brewery in 1931 and in 1933 the Winchester & District Co-operative Society acquired the building for their bakery. The building was demolished in the early 1960s and the Greyfriars flats built in its place.

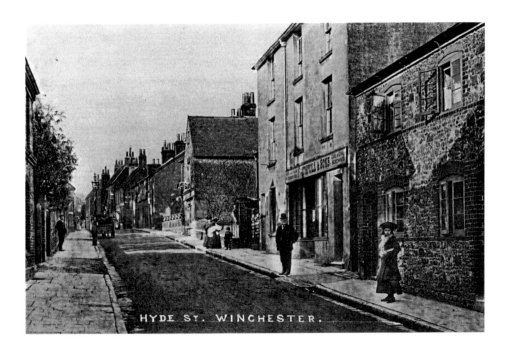

Hyde Street

Mr A. Faithfull, coal merchant, stands outside his premises in Hyde Street around 1907. The business closed in the 1940s, but looking at the building today not much has altered. The house next to it was demolished in the 1960s to construct Hyde Place. On the whole Hyde Street remains relatively unchanged.

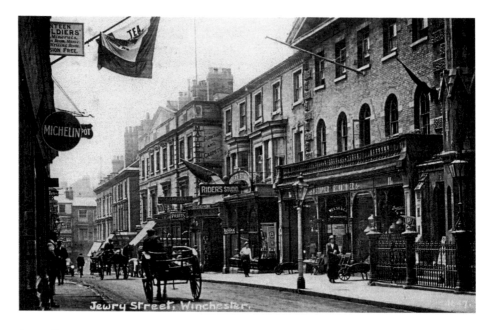

Jewry Street

The old gaol was first built in 1805 and used as a debtor's prison until 1849 when a new gaol opened on Romsey Road. The building became one of the first libraries in the country and at the time this photograph was taken, around 1916, it was occupied by Stopher's Ironmongers. It is now the Old Gaolhouse pub. The church next to it was built in 1853. On the other side at No. 11 was Rider's photographic studio, which is also now occupied by the pub.

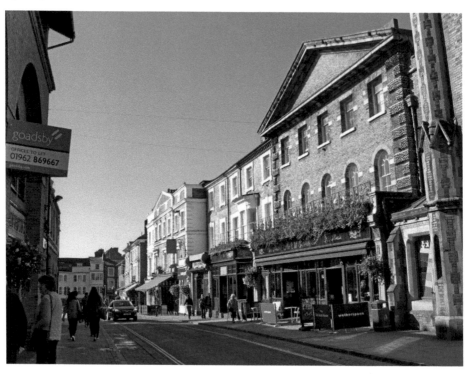

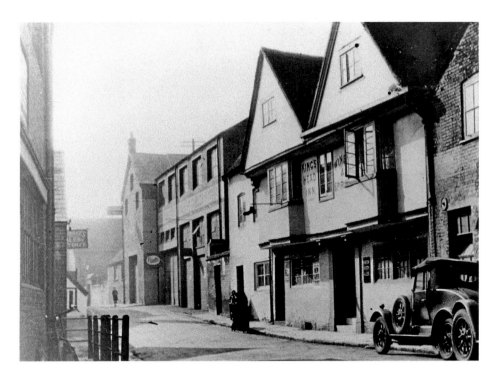

Little Minster Street

The Kings Head, which dated from around 1660, was where the Winchester Lodge of Freemasons met between 1806 and 1816. It was closed in the early 1930s and the car stands outside what was then the Minster Garage. On the left is the rear entrance to The Old Vine inn, which dates from the eighteenth century. It has an attractive frontage on the parallel Great Minster Street, with pleasing views across to the cathedral.

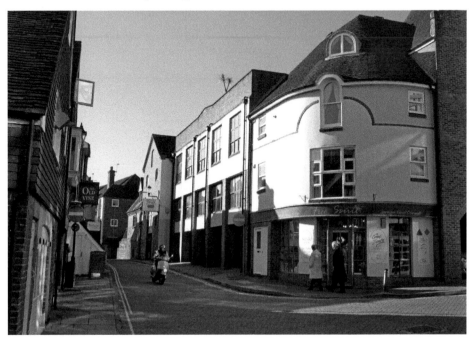

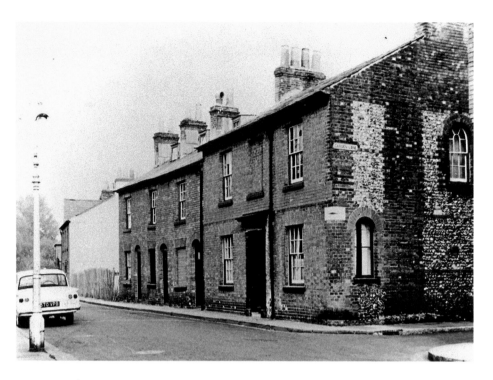

Lower Brook Street

Each of the three Brook Streets once had a brook or stream running down it. In medieval times, Lower Brook Street was known as Tannerestret (its continuation on the other side of Friarsgate is still called Tanner Street). New houses were built in the redevelopment of the 1960s, although Garden Lane still remains.

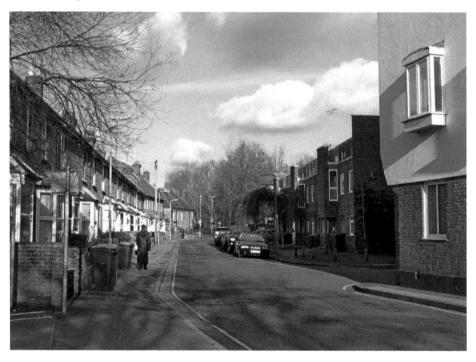

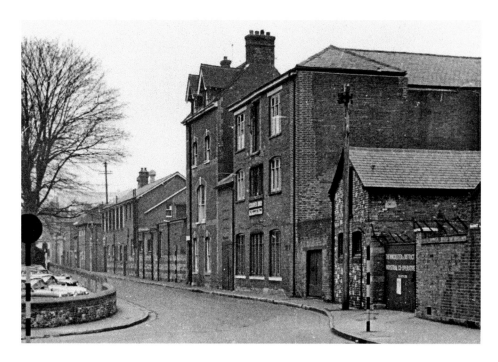

Market Lane

This photograph shows the lane not long before the Wessex Hotel was built. The premises of the Winchester Industrial Co-operative Society, Cooper Bros. and Sheriff and Ward, which all fronted the High Street, had been there since before the First World War. You can just see the entrance to Paternoster Row on the left, which now passes underneath the Wessex Hotel.

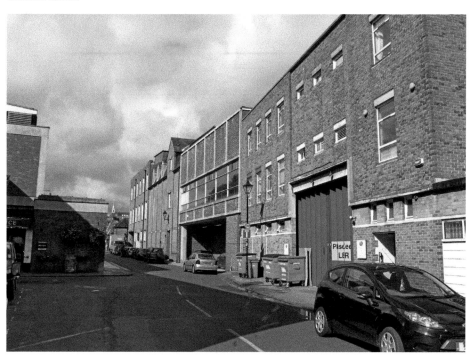

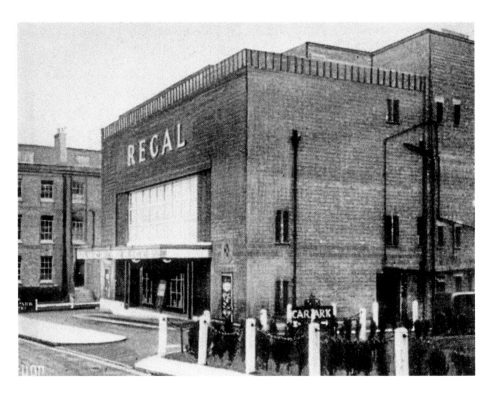

North Walls

The Regal Threatre was built in 1933 on land where St Swithun's students had once played tennis and rounders; the school had moved to Magdalen Hill in 1931. In 1935 the Regal became the Odeon cinema until the Star Group took control in 1971, completely updating the building and introducing bingo. In 1988 it was sold to developers, much to the disappointment of Winchester filmgoers who were without a cinema for several years. The site is now occupied by retirement homes.

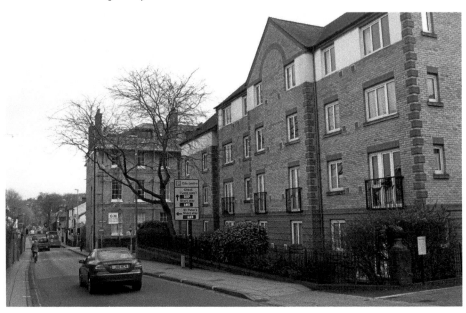

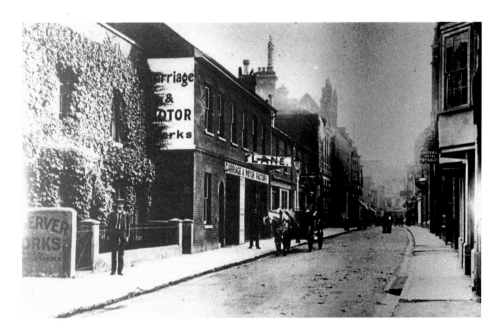

Parchment Street

Parchment Street was once known as *Flesmangerestret* (Fleshmonger Street) until the name was transferred to St Peter Street. The owners of the business advertising 'Carriage and Motor Works' ceased trading in 1906, but the sign still remains today. In the bottom left-hand corner you can see a sign for 'Observer Works'; the *Hampshire Observer* newspaper moved to Staple Gardens in 1905, having been bought by William Thorn Warren in 1896. Warren & Co. continued to publish it until 1957.

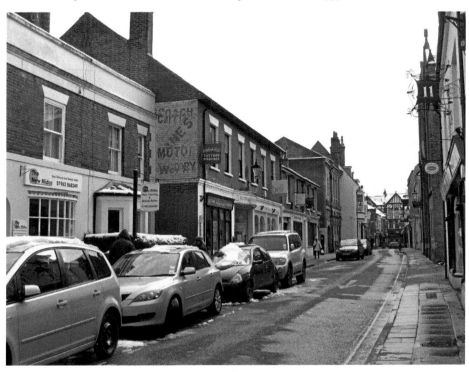

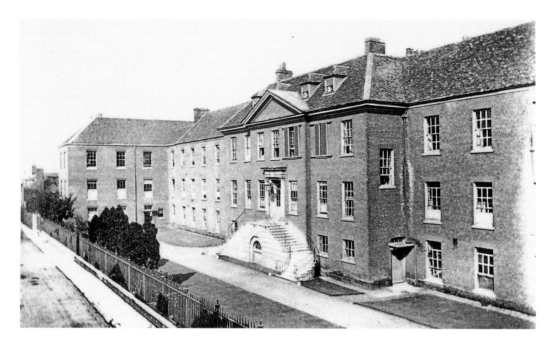

Parchment Street

The County Hospital was located here before it moved to its new site on Romsey Road. This photograph was taken around 1865. Life expectancy at this time was fifty years; lower than the national average due to the poor drainage and sanitation of the city. After much dispute, drains were finally built in 1878. Today Parchment Street is a healthy blend of residential property, independent shops, hair and beauty salons and an art gallery.

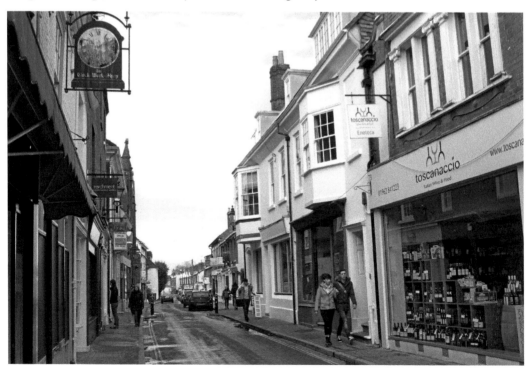

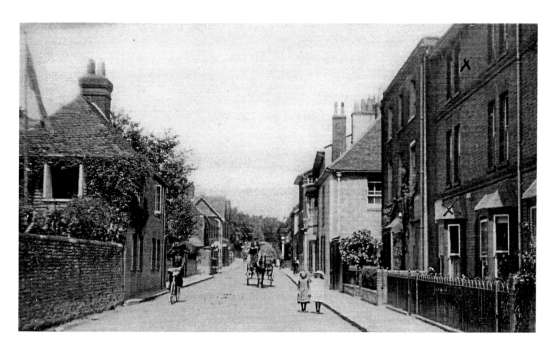

St Cross Road

St Cross Road, looking towards the city around 1912, with the junction of Stanmore Lane in the distance. Just before this junction was the Wheatsheaf public house, which became a wine shop in the 1970s and finally closed in 1990. A hundred years ago the road was known as Front Street, and Back Street still runs parallel behind the houses on the right.

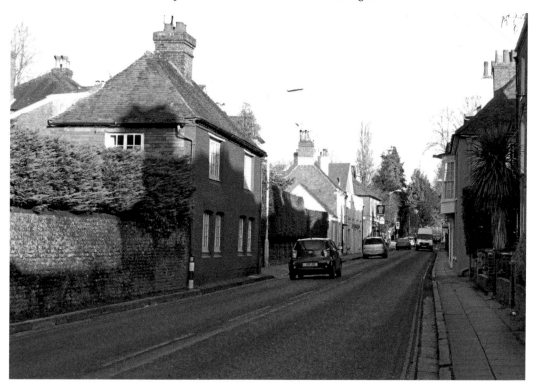

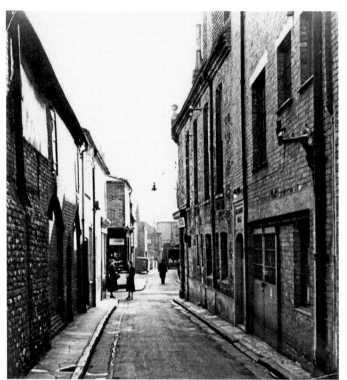

St George's Street

What is now the main route through Winchester, this is St George's Street in 1956 before it was widened and the buildings on the left were demolished. On the right was the Masonic Hall (the words are still above the doorway), which dated from 1867 and was originally a Wesleyan chapel. W. H. Smith extended into this former hall, which now is occupied by the post office. By coincidence, on the old corner of Parchment and St George's Street, where the two women are standing, was the Post Office Tavern, the post office being situated in Parchment Street.

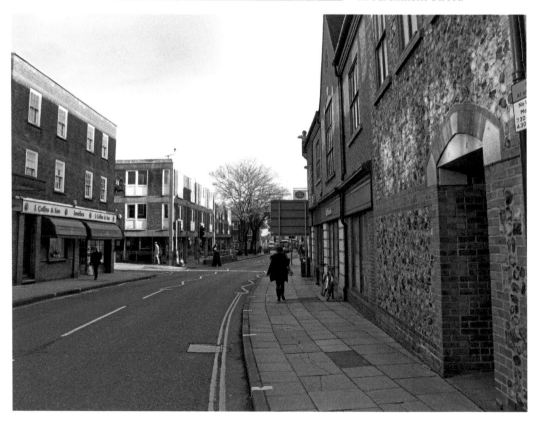

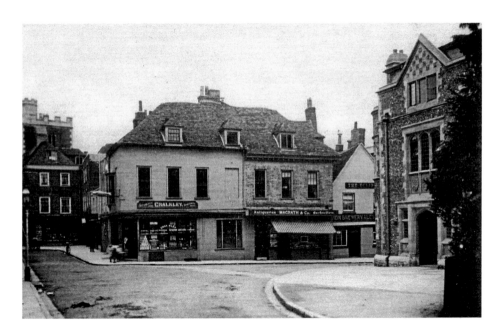

The Square

According to *Warren's Guide* Magrath's bookshop was only in business between 1905 and 1906, and so dates this photograph. The City Museum opened in 1903, one of very few purpose-built museums outside London. The Eclipse Inn was so named because of the nearby Sun Inn. Its distinctive timber framing reappeared in the 1920s when the building was restored and the plaster covering it was removed. As well as this pub, there are several restaurants and cafés on the left making the area a popular spot for al fresco dining.

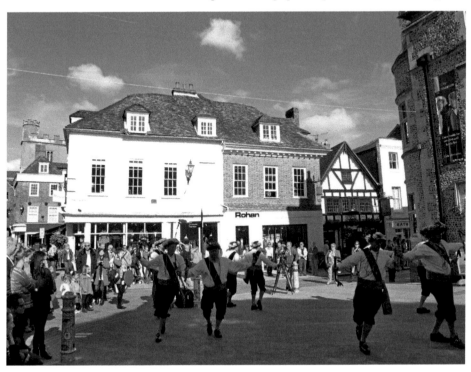

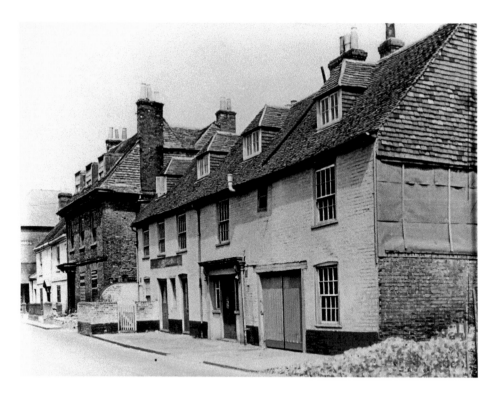

Upper Brook Street

The Queen's Head was one of eighteen public houses that existed within the three streets which make up The Brooks. In the late eighteenth century it was the headquarters of the Winchester-London carriers and stood on what is now the road running alongside The Brooks shopping centre. The building was pulled down in the late 1950s and the area between Upper and Middle Brook Street became a car park for many years. Further development came in the 1980s; the area was excavated before The Brooks shopping centre was opened in 1991.

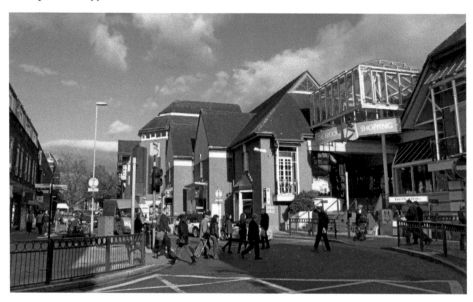

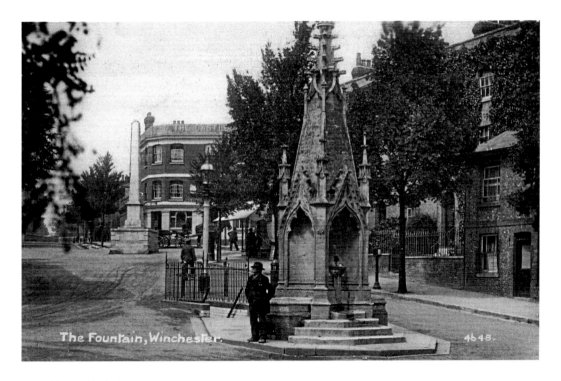

The Fountain, Winchester. 4648.

Upper High Street

The drinking fountain was erected by Lancelot Littlehales in 1880 but later moved to Oram's Arbour in 1935 to make way for a traffic island. Provision of public water supplies by private donation was not uncommon. (Another example of this is the horse trough in Jewry Street, a memorial to those animals that died in the Boer War.) The railings to the left of the fountain surround the steps down to underground toilets. The Castle public house building on the corner of Sussex Street has now been converted to apartments.

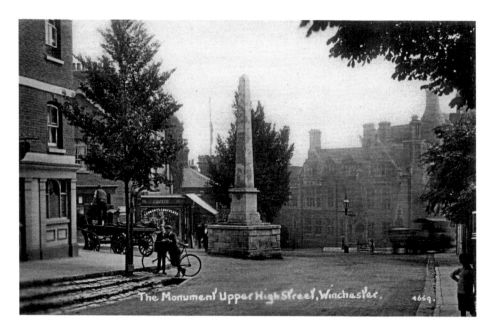

The Monument Upper High Street, Winchester.

Upper High Street

The Plague Monument was erected in 1759 by the Society of Natives to mark the spot where money was exchanged for goods at the time of the 1665 plague. People brought their produce to this point outside the West Gate and waited (at a distance) for the townsfolk to bring out their payment, which was left in a bowl of vinegar to disinfect it. The confectionery shop on the corner advertising Cadbury's chocolate was numbered as part of Upper High Street and was there until 1922.

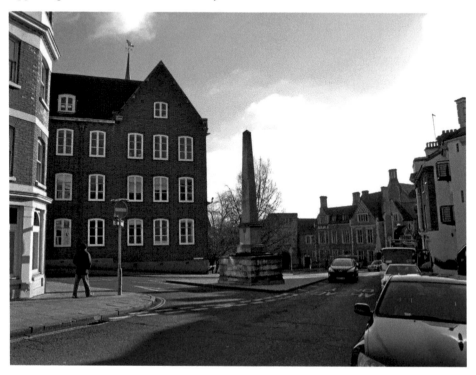

Wales Street

This wonderful street scene was taken around 1902. The sign of the Wheatsheaf Inn can be seen on the left; this was at No. 4 Wales Street and the Ship Inn was next door at No. 5. By 1910 only the Wheatsheaf was still in business and in 1916 it changed its name to The Ship Inn. The houses on the right have gone and the road has been widened. This is now a main traffic route as Wales Street continues into Easton Lane, which links to the motorway.

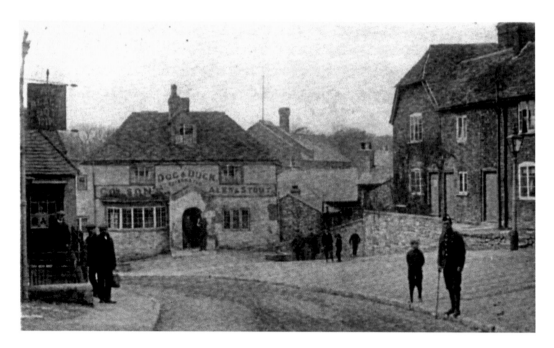

Wharf Hill

Wharf Hill at the time of the First World War. The Dog & Duck closed in 1923 but wasn't demolished until 1937. There were once four pubs in the area but now only the Black Boy remains, a building which traded as a public house for over two hundred years. Wharf Mill, now visible behind the trees where the Dog & Duck stood, dates from 1885 and was converted into apartments in 1970.

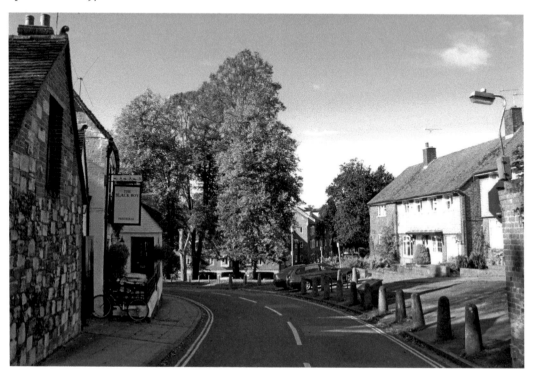

High Street from the West Gate

An early twentieth-century view of the High Street with no motor vehicles in sight. Down below at No. 80 was John Hodder, a cabinetmaker and upholsterer, who ceased business in 1914. This premises is now Mailboxes. The first road on the left past the tree is Staple Gardens. This is where the warehouses and a great weighing machine of the wool market stood when Edward III made Winchester a wool staple town in the fourteenth century. The County Council office buildings on the right are essentially unchanged.

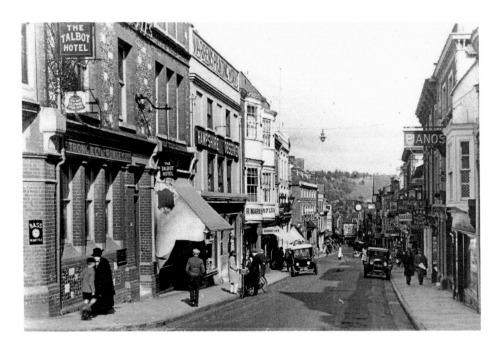

Numbers 83 & 85 High Street

The Talbot Hotel on the corner of Staple Gardens replaced the Star Inn in 1929 and is now GA Property Services. At No. 35 is Warren & Son, which started in 1835 as a printer and publisher then operating in Parchment Street. Nathanial Warren moved to the High Street premises in 1859, where the company continues as a successful stationer's. Over the road was the music shop Whitwams (note the sign for pianos), which traded on the High Street until 1999.

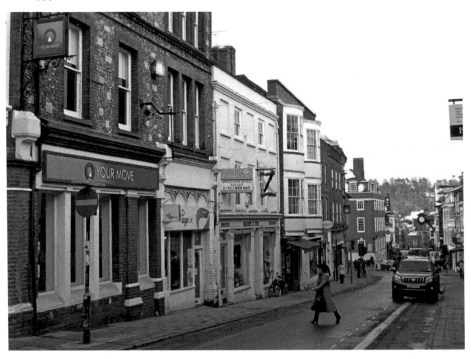

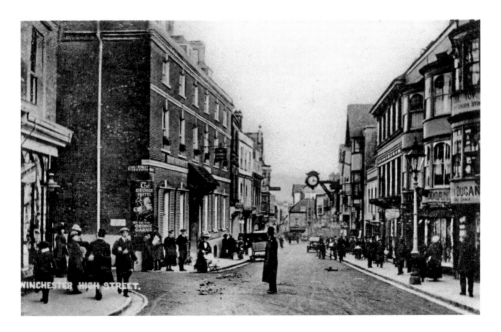

Junction of Southgate Street, High Street and Jewry Street

This busy intersection was controlled by a point duty policeman until 1934 when traffic lights were installed. At this time all London to Southampton traffic passed through Winchester until the bypass was constructed in 1938, but the continual increase in traffic led to the road eventually being widened. The George Hotel that had stood on the corner was sacrificed and Barclays opened in 1957. In 1974 the High Street was pedestrianised between Market Street and St Thomas Street, diverting the flow of traffic up St George's Street or along Jewry Street.

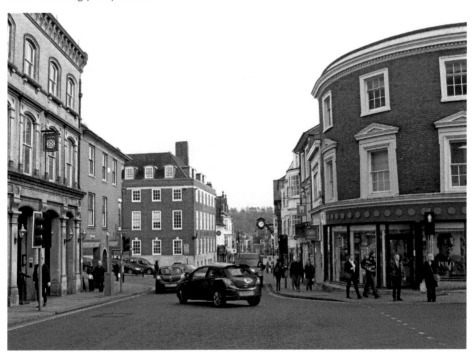

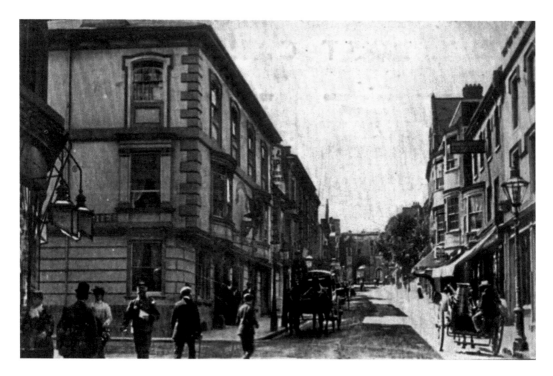

Black Swan Buildings, Southgate Street

This hotel featured in *The Adventure of the Copper Beeches* where Sherlock Holmes met Miss Hunter. A keen photographer, Arthur Conan Doyle may well have stayed at the hotel for its advertised photographic darkroom facilities. Sadly the building was demolished in the 1930s, but the block of properties on this corner is collectively known as Black Swan Buildings. A replica of the original Black Swan statue hangs on the corner.

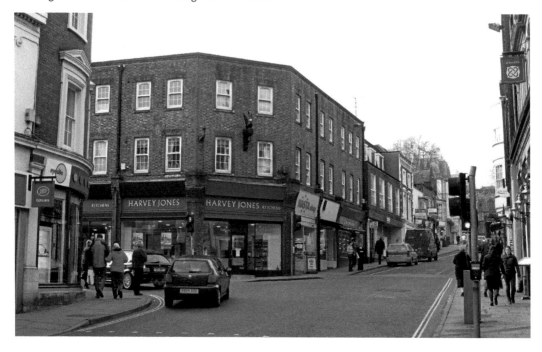

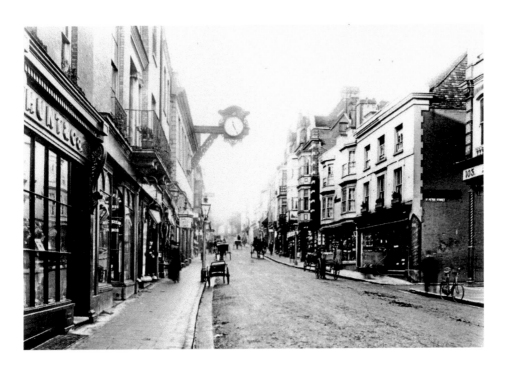

Lloyds Bank

This building was the original Guildhall, used from the reign of Edward IV to James II, after which it fell into decay. It was rebuilt in 1713 after a visit by Queen Anne, and it was at this time that the great bracket clock – of which the present one is a replica – was added. On the left is Hunt & Co., chemists since 1861. The shop is now the Edinburgh Woollen Mill, but the chemist's shop is on display in the city museum. On the right, note the very different appearance of God Begot House.

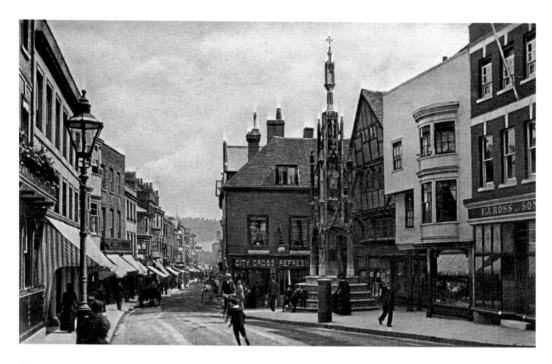

Buttercross

This fifteenth-century High Cross was saved from removal in 1770 by angry citizens, after hearing that a wealthy landowner fancied it as a garden ornament. In the nineteenth century it was in danger of demolition but once again there was opposition, and fortunately it underwent restoration instead. In the same century it became known as the Buttercross when a dairy market was held in the area. The photograph above is from around 1900 and the one below is from 1953.

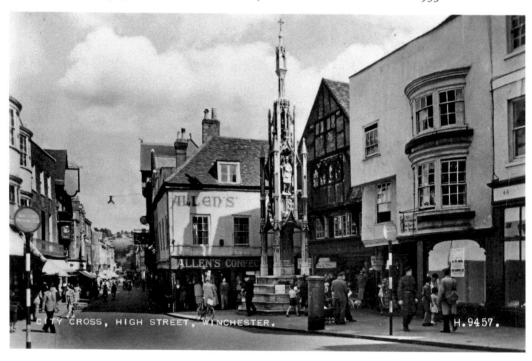

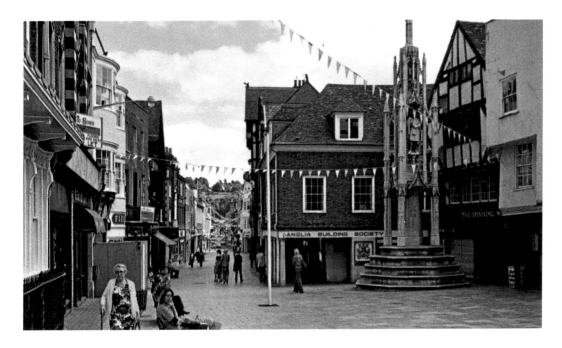

Number 41 High Street

City Cross refreshments closed in 1904; then followed Allen's the confectioner's, which was in business for over fifty years. The photograph above is from the 1970s (possibly at the time of the Silver Jubilee in 1977 – spot the Union Jack flag further down the High Street) when No. 41 was the Anglia Building Society. Now the premises is a confectioner's once again in the shape of Montezuma's innovative British chocolate.

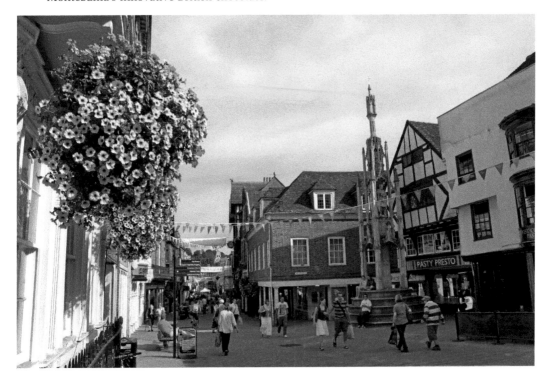

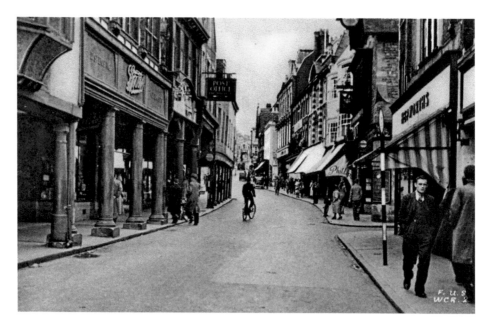

The Pentice

A need for shops to expand but not encroach on the road led to the upper floors of these sixteenth-century buildings being extended. For a time it was also known as the King's Mint after the thirteenth-century Royal Mint that had existed here. In 1903 Boots the chemists purchased their property from Gudgeon & Sons for £4,150. At the time of the 1950 photograph, Townend's was at No. 30 – The Pentice, a 'Tailors & Outfitters for Fathers & Sons'. Until recently this was Thomas Cook and is now The White Company.

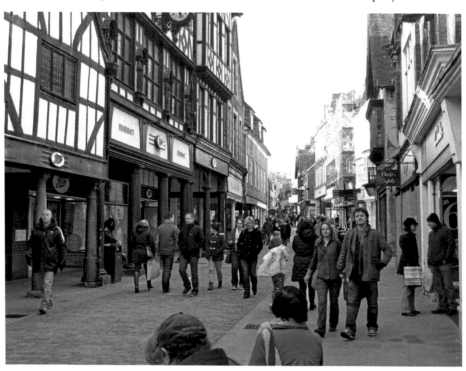

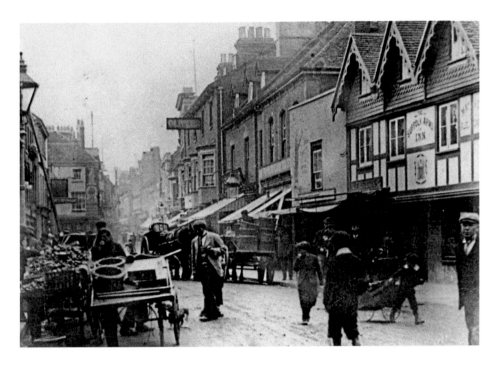

Number 138 High Street

Barrow traders in High Street just before the turn of the twentieth century. The Suffolk Arms pub was replaced by Marks & Spencer in 1935, which later expanded further up the street. The windows of the buildings next to this store are the same, as are those on the building on the corner of Market Street, now Monsoon. This spot has become a prime market trading spot, including the new Sunday markets.

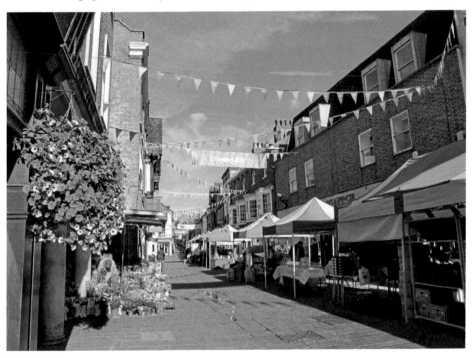

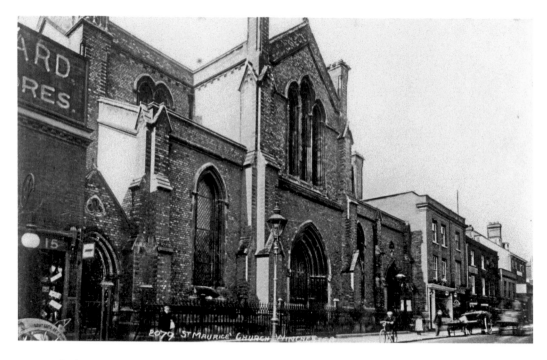

St Maurice's Covert

Originally backing onto the cathedral grounds, St Maurice's was a church of medieval origin. It was rebuilt in 1842 but retained and incorporated the tower and its Norman doorway. These are now the only surviving parts to be found under St Maurice's Covert, the covered area next to Debenhams which is a regular spot for charity stalls. The church was demolished in 1957.

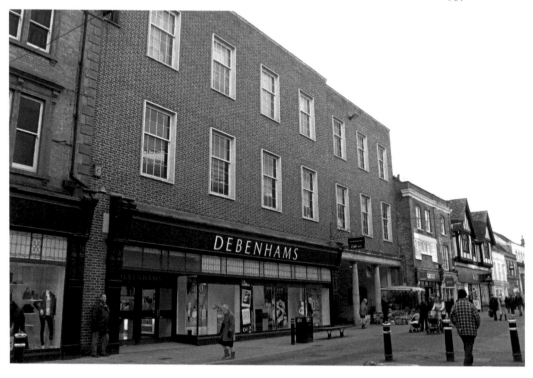

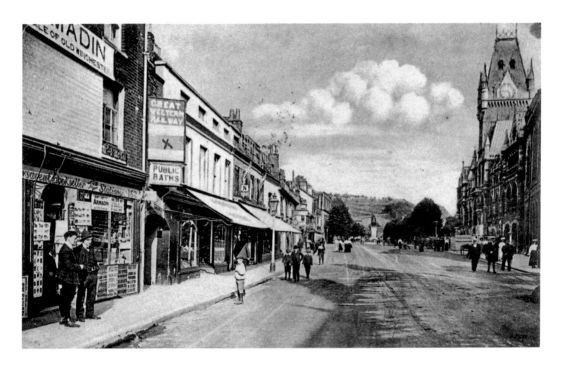

Number 155 High Street

In his 1895 history of Winchester, Alderman Thomas Stopher stated that the occupier of 155 High Street, a baker named Henry Butcher, established the first Turkish Baths. Mrs Butcher attended the women's sessions. The last directory entry was for 1881, but by 1884 it had been taken over by A. Dumper, who already owned several shops in the High Street. The property at 155 is still attending to health requirements in the form of Lloyds Pharmacy, although next door is the rather tempting Maison Blanc patisserie.

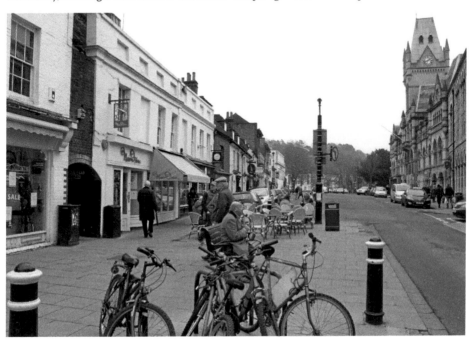

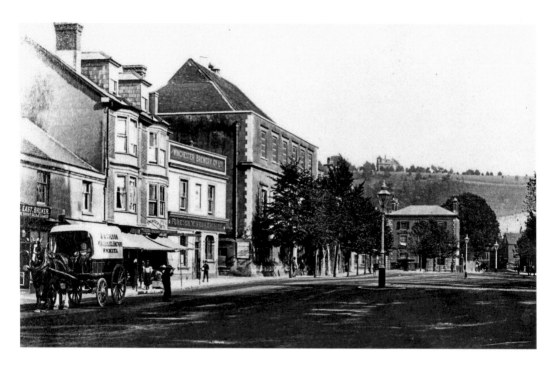

Broadway

The eastern end of High Street became known as the Broadway around 1800; this photograph was taken before 1901 as King Alfred's statue has not yet been erected. The Crown & Anchor is still named, and was once owned by the Winchester Brewery Company. The Broadway has seen many processions, military and royal, over the past century. It is still occasionally closed off for events such as the annual Hat Fair, and the torchlit procession on Bonfire Night. It is more often seen as a place where coaches, taxis and buses vie for space.

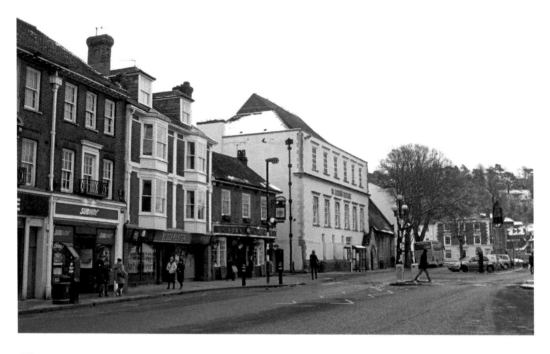

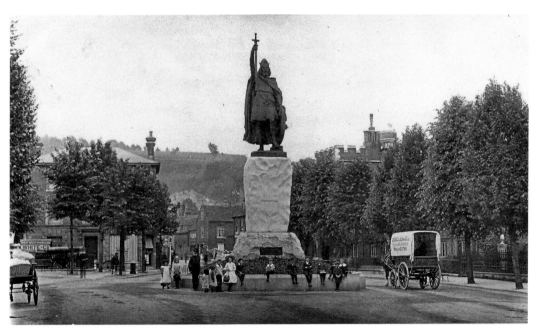

King Alfred's Statue

King Alfred was crowned King of Wessex in 871, making Winchester his capital. To mark the millennary of his death in 1901 (although it was later known that he died in 899) crowds of hundreds showed up to see the unveiling of the bronze statue, and the day was declared a public holiday. Visitors to Winchester arriving by coach are greeted by this impressive city landmark. Crowds enjoyed the statue as a viewing platform when the Olympic torch passed through the city in July 2012.

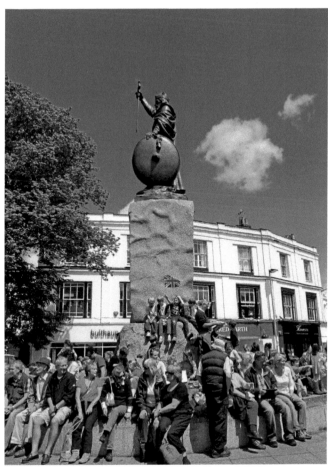

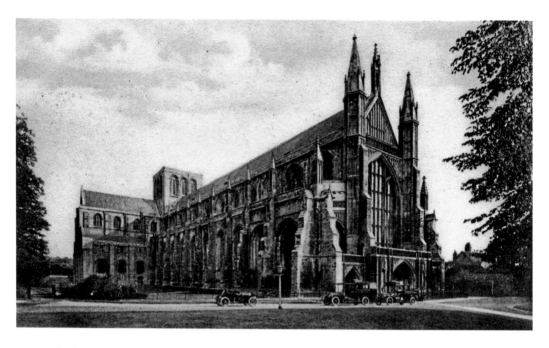

Winchester Cathedral

Founded in 1079, Winchester Cathedral is the longest medieval church in Europe. Over the years it has witnessed many historic events, including the second Coronation of Richard I in 1194, the marriage of Queen Mary and Philip II of Spain, and the funeral and burial of Jane Austen. Today it attracts 300,000 visitors a year for its many tours, musical events and graduation ceremonies as well as its wealth of history.

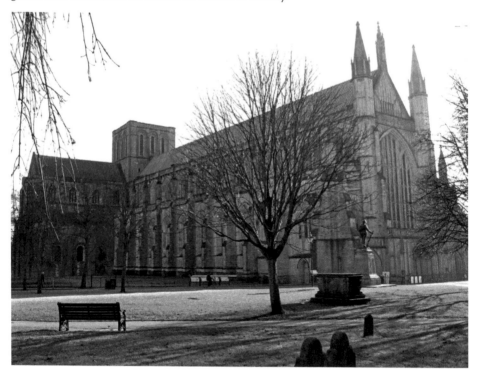

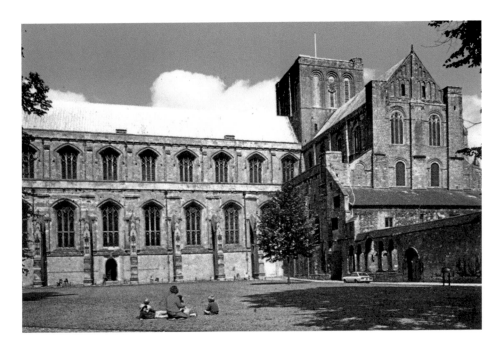

South-West Transept of Cathedral

When diver William Walker had completed his mammoth task of saving the cathedral from subsidence in the early 1900s, the walls were underpinned and an imposing line of buttresses built on the south side of the building. Sitting near these you can often hear choral practice beyond the walls; in December the wooden chalets of the Christmas market line the Close and surround the ice-skating rink.

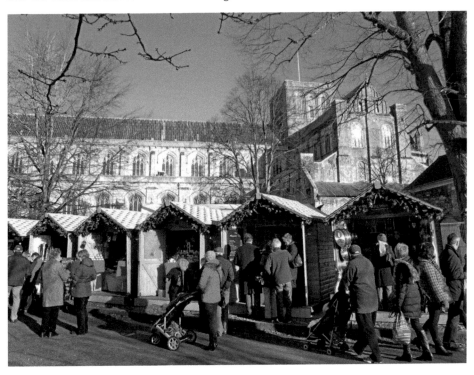

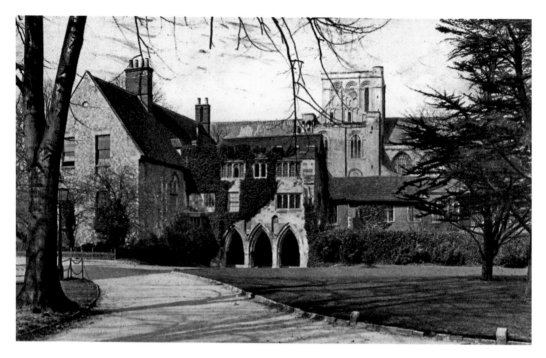

The Deanery

Tucked away in a corner of the Cathedral Close, the Deanery retains the peaceful atmosphere of a former monastery. Once the prior's lodgings it was substantially rebuilt in the seventeenth century, although the thirteenth-century vaulted porch still remains. This inviting piece of architecture now leads us into the Deanery's second-hand charity bookstall.

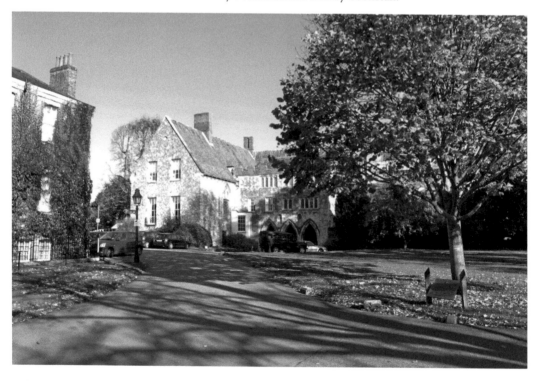

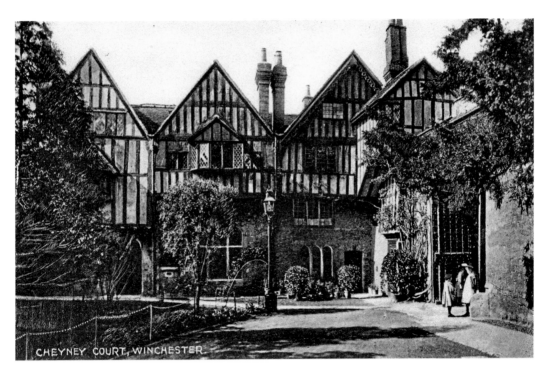

CHEYNEY COURT, WINCHESTER

Cheyney Court

Possibly the most photographed buildings in Winchester, after the cathedral, and ones that have changed the least, Cheyney Court is of the late sixteenth century. This was the site of the Court of the Bishops of Winchester in an area known as the Soke. The exit from the Cathedral Close is through Priory Gate, the nail-studded doors of which are locked at ten o'clock every night.

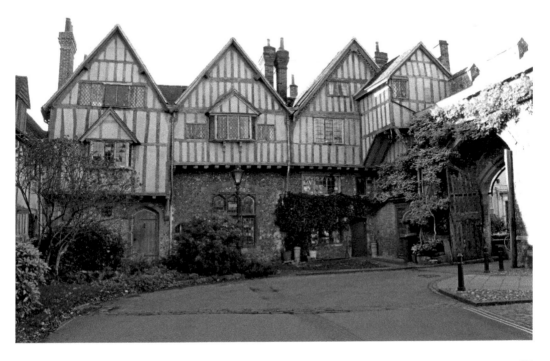

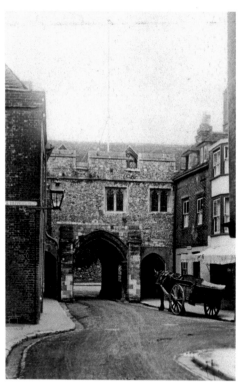

King's Gate

This is the second of the two medieval gateways still in existence in Winchester, and is quite possibly on the site of the original Roman south gate. Above it is housed the tiny chapel of St Swithun upon Kingsgate. The shops on the corner of College Street were demolished in the 1930s, the space filled with walled gardens. The appeal of the area for period location settings has attracted film companies, and in 2012 a scene for the screen adaptation of *Les Misérables* was filmed under the archway.

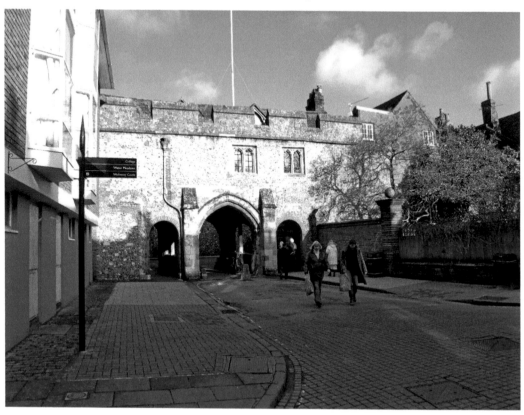

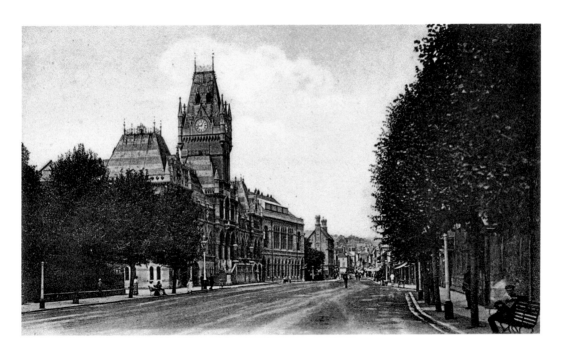

Guildhall

Opened in 1873 at a cost of £10,000, the Guildhall contained the city council chambers, magistrates court, museum, police station and fire station. If that wasn't enough, in 1876 the West Wing was added, which housed the School of Art, library and reading room. It recently underwent renovation of its rooms and continues to play host to many civic events, weddings and banquets. The ground floor also houses the tourist office and the new Eighteen71 Café – the date the first foundation stone was laid.

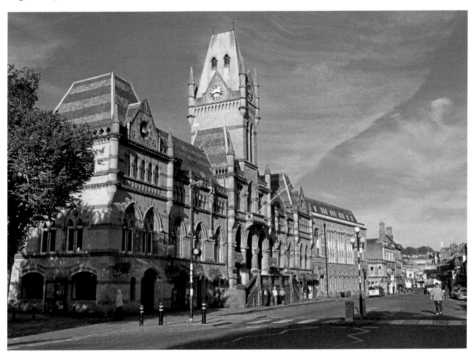

City Mill

Powered by the fast-flowing River Itchen, this rare example of an urban corn mill was first recorded in 1086. After it was given by royal charter to the city by Queen Mary in 1554, it became known as the City Mill. Rebuilt in 1743, it continued to be used until 1928 when it was sold and used as a youth hostel. It is now owned by the National Trust who undertook a restoration project, and since 2004 the mill has been grinding flour again.

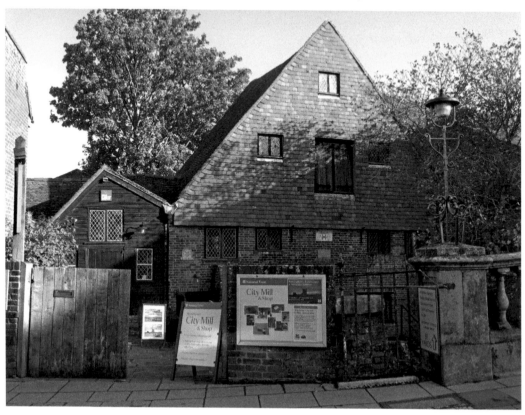

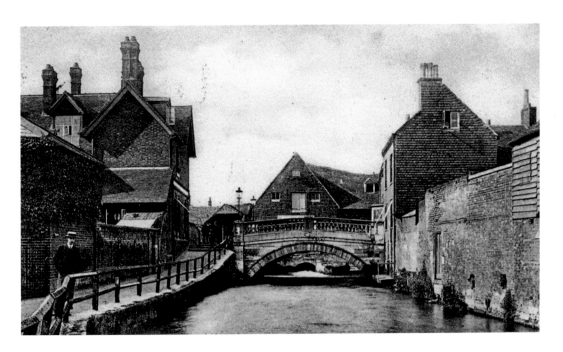

City Bridge

St Swithun, the Anglo Saxon Bishop of Winchester, was believed to have built the first bridge here over the Itchen in the ninth century. Legend tells of an act of kindness to a poor woman who was crossing the bridge carrying a basket of eggs when she was jostled and the eggs broke; the saint took pity on her and made them whole again. The bridge has been replaced many times; the present structure dates from 1813. The old postcard dates from 1910 and little has changed in the scene today.

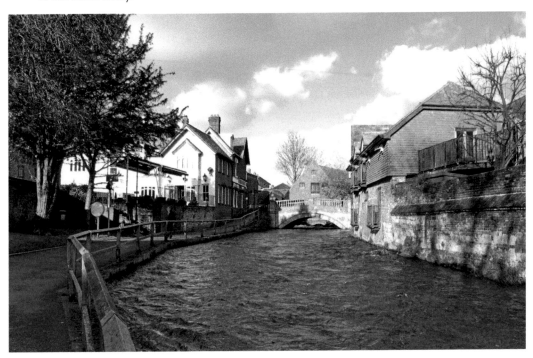

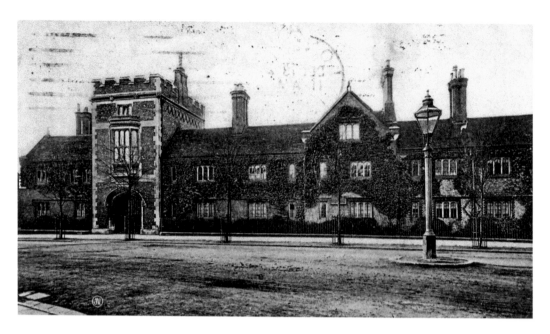

St John's Hospital, Broadway

One of the oldest charitable institutions in the country, originally founded by St Brinstan, Bishop of Winchester, around AD 931–34. The first reference appears in the late thirteenth century with the endowment by John Devenish of the chapel in the Broadway, which was dedicated to St John the Baptist. The hospital adopted the name and gave support to the old and infirm, needy travellers and the poor of the city. Today the charity is the largest independent provider of care for older people in Winchester with its almshouse accommodation, day centre and two nursing homes.

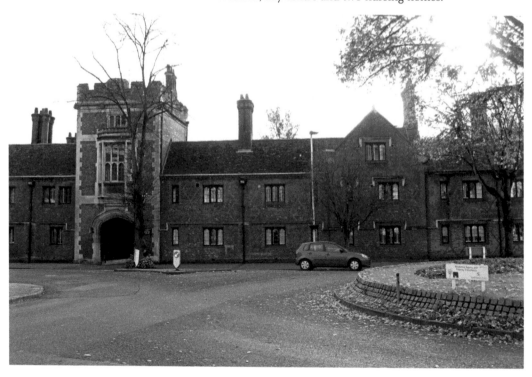

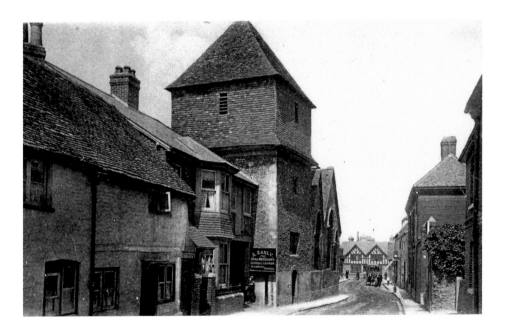

The Chesil Theatre

Dating from the twelfth century, St Peter's church in Chesil Street sadly fell into disrepair after the Second World War. When the Winchester Preservation Trust was formed in the 1960s one of its first tasks was to save the church from demolition. The Winchester Dramatic Society moved in rent free on condition they maintained the building. The success of the Chesil Theatre has not only seen this, but has also enabled the company to purchase the adjoining property for expansion.

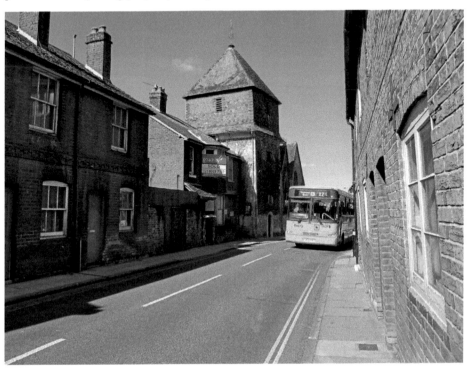

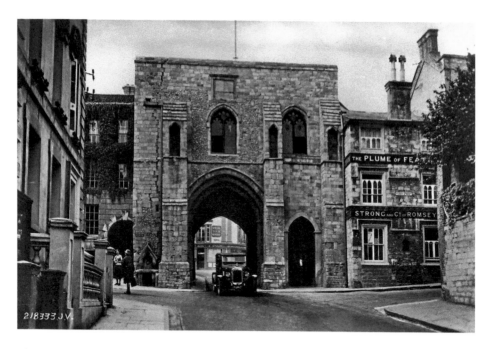

The West Gate

The impressive fortified West Gate stands at the upper end of the High Street. Built on the site of the original Roman gate, the current stone dates back to the thirteenth century. It served as a debtor's prison for 150 years, a clubroom for the Plume of Feathers pub and now houses a small but interesting museum. The top affords fine views over the High Street to St Giles Hill.

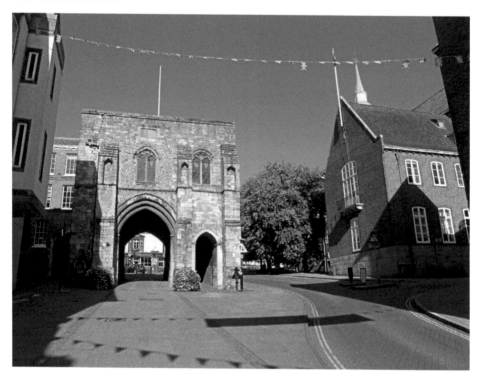

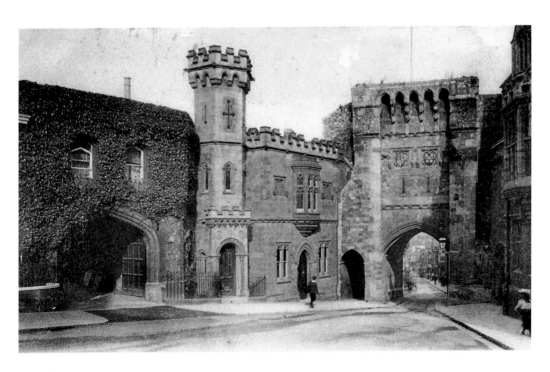

The West Gate

Pedestrians risked life and limb entering the city through the one opening until 1791, when the side entrance was made. In 1936 plans had been drawn up for more County Council offices and the buildings to the left of the West Gate were pulled down in readiness, but the Second World War halted procedures. Elizabeth II Court was eventually built between 1956 and 1959, and traffic was finally diverted around the West Gate.

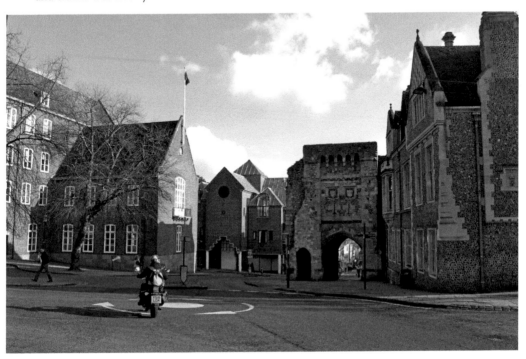

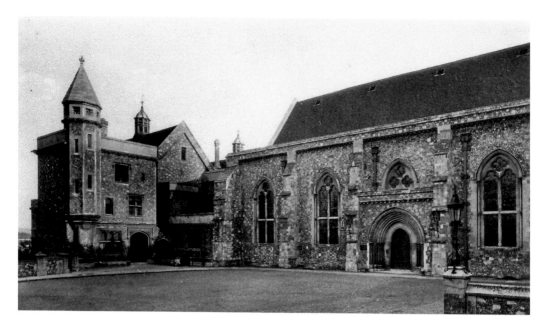

The Great Hall

William the Conqueror's castle was rebuilt during the reign of Henry III, who added the Great Hall which is now the only surviving building, the castle having been demolished after the Civil War. The castle site has been the home of the Hampshire County Council since 1889, and whose offices adjoin the Great Hall. It has long been a site for justice too; before the current Law Courts were opened in the 1970s, the Great Hall saw the trial of Sir Walter Raleigh in 1603, who was condemned to death for treason.

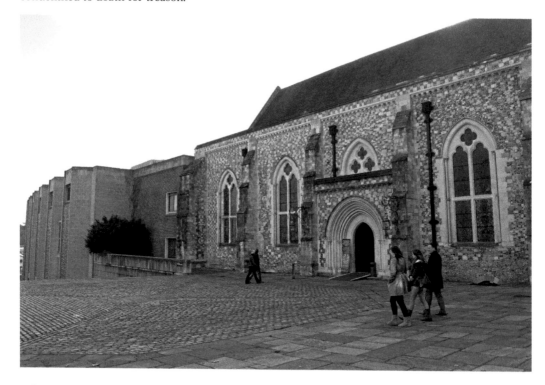

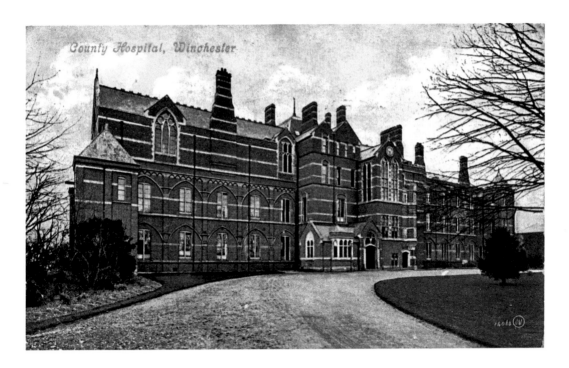

The Royal Hampshire County Hospital

Winchester's first hospital was founded in 1736 and situated in Colebrook Street. It moved to Parchment Street but site and drainage problems meant relocation to higher ground. Florence Nightingale advised on this new site in Romsey Road, and the architect William Butterfield designed the new hospital which was opened in 1868 with just fourteen patients and sixteen outpatients. Further wings were added throughout the twentieth century and the hospital now has over 500 beds.

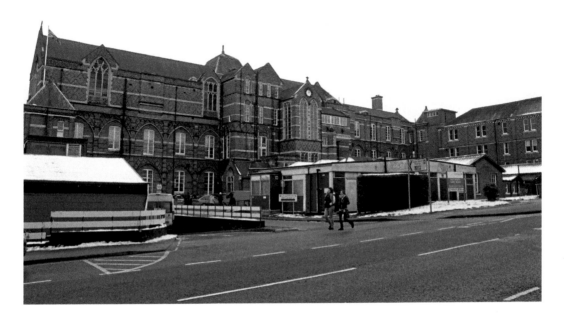

Winchester University

With its aim to produce qualified teachers, the Diocesan Training College was one of the great contributions to Hampshire society in the mid-nineteenth century. The current building opened in 1862, and in 1928 it became known as King Alfred's College. It further expanded into a College of Higher Education, gained university status in 2005 and now has over 5,000 undergraduates.

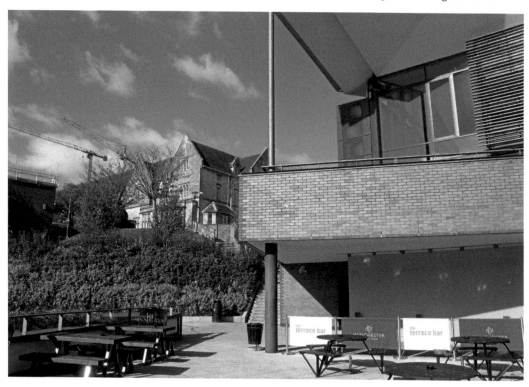

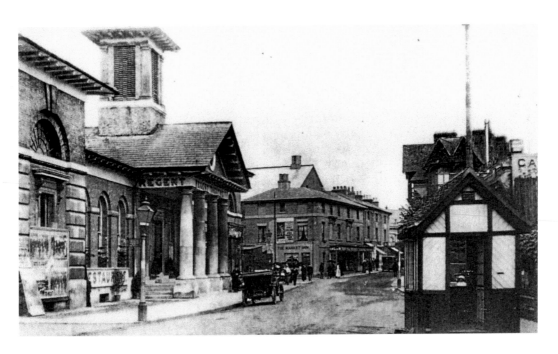

The Discovery Centre

The Corn Exchange was built in 1836–38 of yellow brick to the design of local architect Owen Carter. The Tuscan portico is believed to be modelled on that of St Paul's church in Covent Garden. At the time of the above photograph it was the Regent cinema and restaurant; it opened as a library in 1936. When the building was recently refurbished, architects returned to Carter's original scheme and re-established the classical layout. It reopened as the Discovery Centre in 2007.

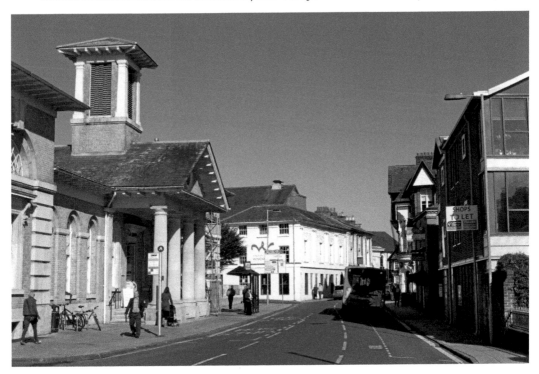

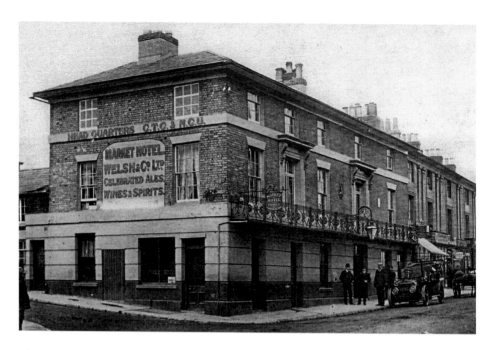

Theatre Royal

At the time of this photograph, around 1907, the Market Hotel was also the headquarters for the Cyclists Touring Club (CTC) and the National Cyclists Union (NCU) – see side of building. In 1914 it became a theatre, and then from 1920 a cinema, continuing as such until 1974. It was saved from demolition and purchased by the Winchester Theatre Fund, and with the aid of grants, trusts and fundraising, has undergone much renovation.

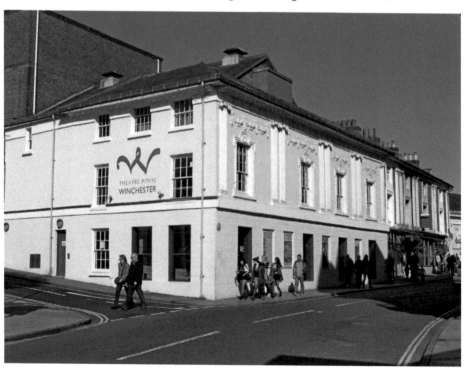

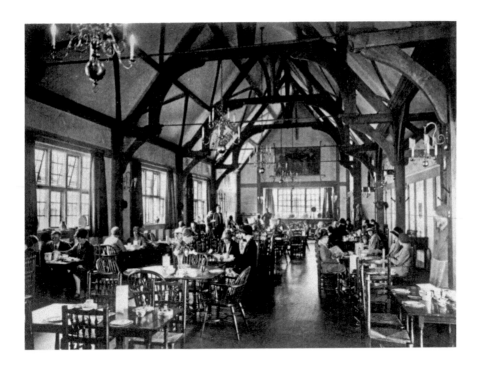

W. H. Smith

This building of 1927 is an example of Arts and Crafts/Domestic Revival style. The first floor, with its impressive murals and timber hammer-beam roof, was originally a tea room and dance hall, and the rear of the shop was a library. On the rounded exterior corner is a fascia of roses, ships and lions that appears to be the Southampton Coat of Arms, which I have seen catch many a photographer's eye.

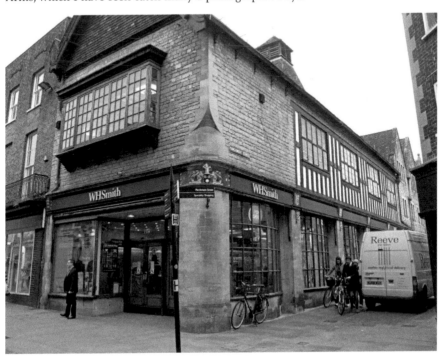

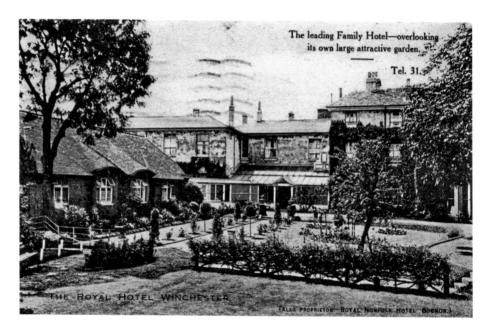

The leading Family Hotel—overlooking its own large attractive garden.

Tel. 31.

THE ROYAL HOTEL WINCHESTER

(ALSO PROPRIETOR ROYAL NORFOLK HOTEL BOGNOR.)

The Royal Hotel

Advertised in *Warren's Guide* of 1907 as 'A high-class old-established Hotel for Families and Gentlemen, in the heart of the City, yet quite apart from its noise', the Royal first opened in 1859, in premises in St Peter Street, which had been vacated by the Benedictine nuns two years earlier. It catered for motorists with a lock-up garage and met others coming by train with an 'omnibus', or horse-drawn carriage. This postcard was sent in 1929 and shows the shady garden at the rear, which continues to provide a welcome retreat for guests.

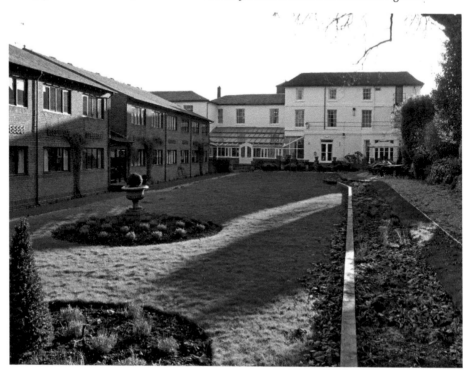

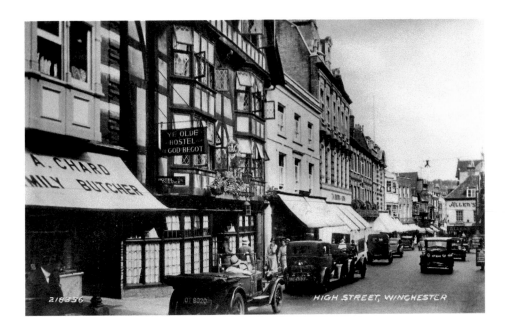

God Begot House

This historic building stands on the site of the God Begot Manor which Queen Emma, widow of King Canute, bequeathed to St Swithun's priory in 1052. The present building dates from the mid-sixteenth century, and although the exterior timber was added in 1908, much of the interior woodwork is original. Over the last hundred years it has kept visitors and residents well rested and well fed through its changes of ownership; it has been a hotel, a tea room and is now a restaurant.

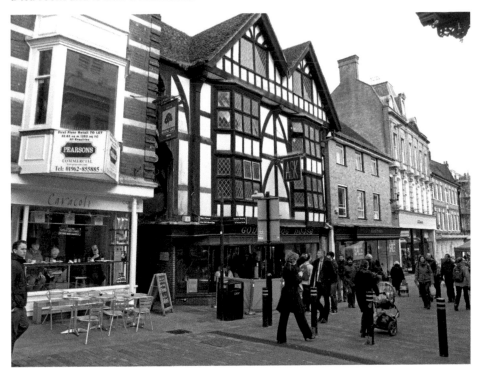

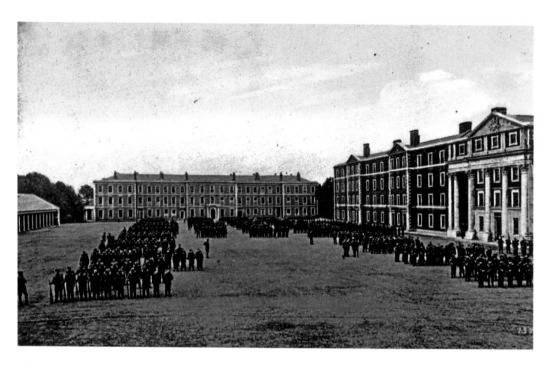

The Peninsula Barracks

These present-day buildings were built on the site of the King's House, which was built for King Charles II. After the monarch's death it became neglected and was converted into barracks in 1796. It became the home of the King's Royal Rifle Corps in 1858 but was destroyed by fire in 1894 and troops were moved to Gosport while the Barracks were rebuilt. In 1986 Flowerdown on the Andover Road took over as the training depot, and in 1994 the Romsey Road site was developed for residential use and renamed Peninsula Square. The site houses five military museums.

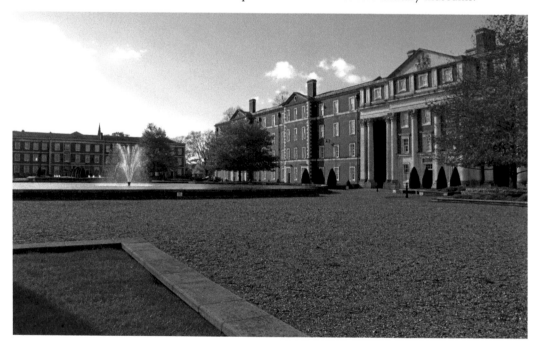

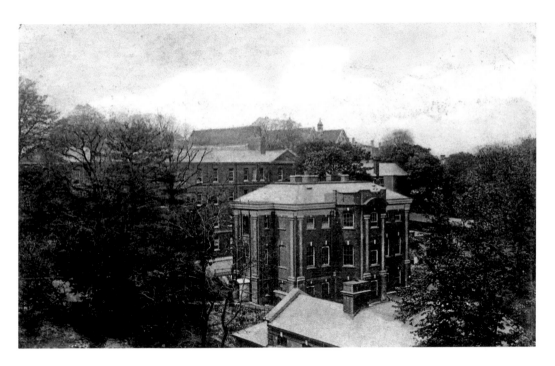

The Everyman Cinema

Barrack buildings as seen from a fairly high viewpoint on Southgate Street. Although the modern photograph isn't of the same view, it is taken from the same street and shows the barracks chapel and schoolroom building of 1851. This was converted into a cinema, which first opened in February 1996 by Emma Thompson at the film premiere of Jane Austen's *Sense and Sensibility*.

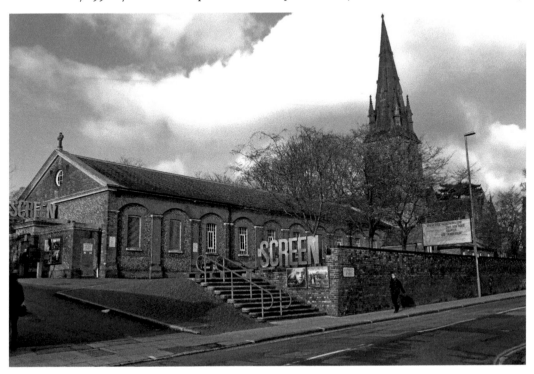

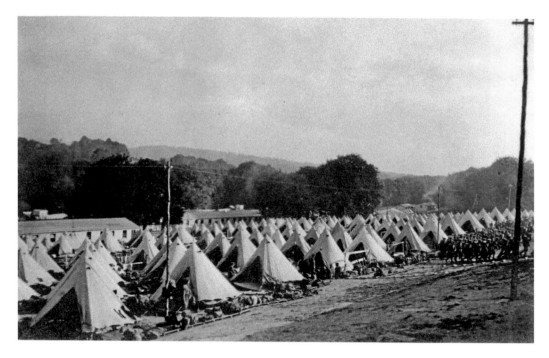

Magdalen Hill Down

During the First World War, many camps were set up to train an ever-expanding army. In November and December 1914 units of the 27th Division formed at Magdalen Hill, or Morn Hill. This camp was situated just to the south of Alresford Road (in the field to the right of the road). Winnall Down Camp was situated to the north behind Winnall Down Farm, which is the group of buildings in the distance on the left.

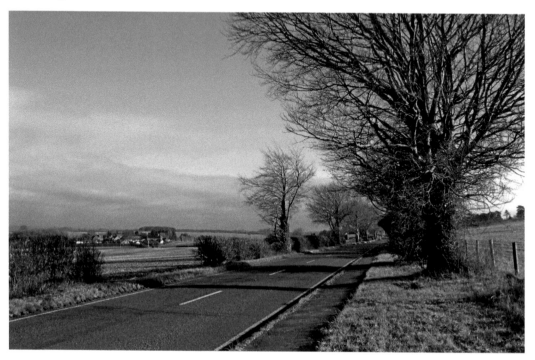

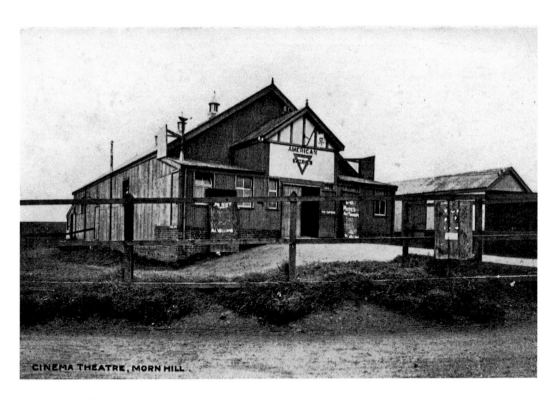

CINEMA THEATRE, MORN HILL.

No Man's Land

This entertainments centre was constructed for the troops in the camps outside Winchester. After the war it was moved to Park Avenue and continued as an entertainments venue under the name New Theatre from 1927 to 1940. This farmland to the north of Alresford Road, where the cinema was roughly positioned, is just outside the city boundary and marked on the map as 'No Man's Land'.

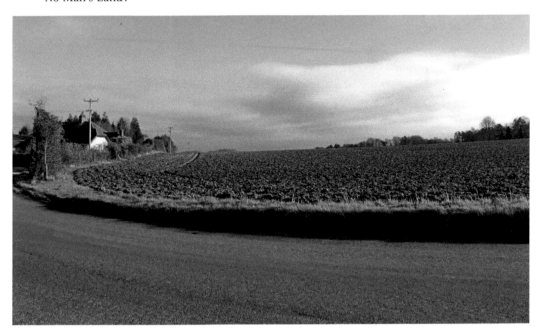

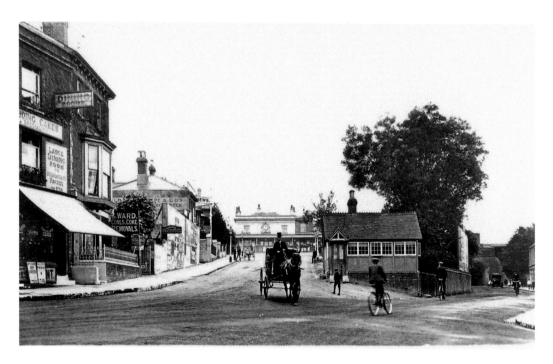

Station Hill

The Turner's Temperance Hotel on the left was renamed Sharp's Temperance Hotel in 1917. The neighbouring Carfax Hotel took over the premises of Sharp's when it closed in 1928 and continued to operate until 1967. The building was demolished in the early 1970s and the site now houses the Hampshire Archives and Local Studies library. The horse-drawn carriage was one of two that regularly plied between the station and the city hotels. The photograph below was taken on a Sunday morning when there appears to be less traffic than there was in 1909.

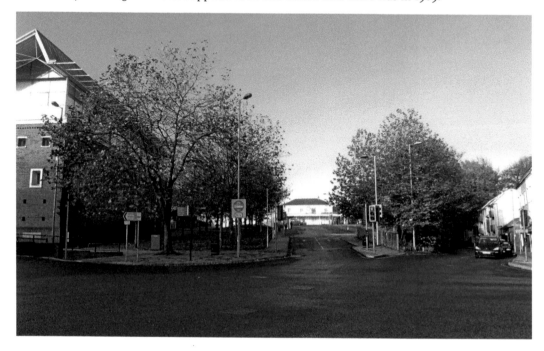

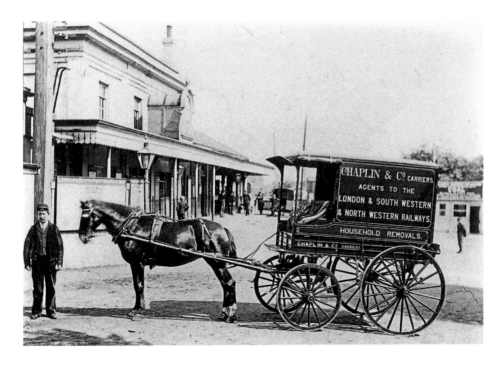

Winchester Station

The London and South Western Railway (L&SWR) station dates from 1838, built by well-known railway architect Sir William Tite. A 1906 guidebook to Winchester shows that the office of Chaplin & Co. was in St Thomas Street and their depository in Hyde Street. In the same guidebook the L&SWR advertises the 'non-stop express corridor dining-car trains' that made the journey from London to Winchester in 85 minutes – not bad going considering today's fastest service is 54 minutes.

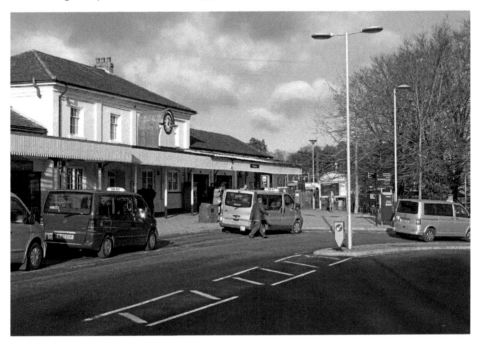

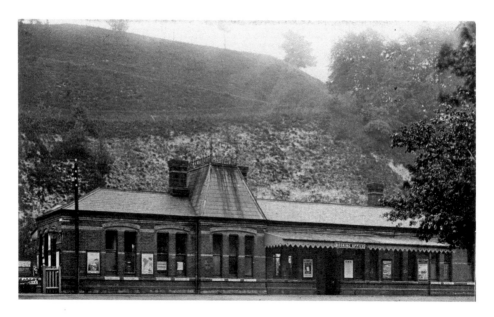

Chesil Car Park (Chesil Station)

The first section of the Didcot, Newbury and Southampton (DN&S) line reached Winchester in 1885, the final stretch being a quarter-mile tunnel through St Giles Hill. The station was tucked to one side of Chesil Street, the only place where land could be purchased at a price the company could afford. Public services to Newbury commenced in the same year, with four trains each way on weekdays. Today Station Approach, next to the Chesil Rectory, is a pedestrian access to the former station yard, which is now offices and a multistorey car park; both are developments of the 1980s.

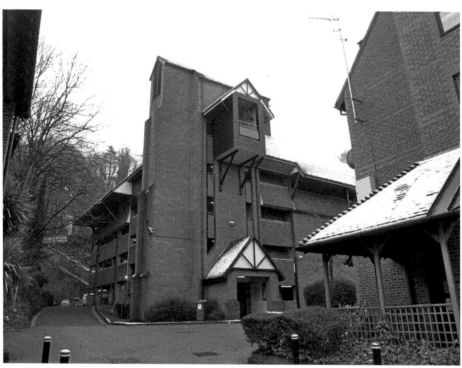

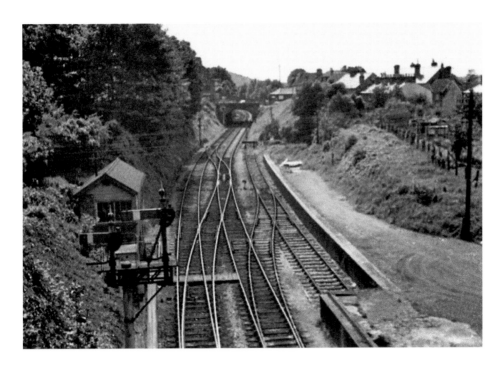

Chesil Car Park

After some financial difficulty, the railway received funds to continue to Shawford Junction. Hopes of an independent approach to Southampton were gone and in 1891 the DN&S railway joined the main London line. With the modernisation of the railways in the 1950s, the line became too expensive to maintain; the station closed in 1960 (the year the photograph was taken). The line has become an alternative exit road from the car parks.

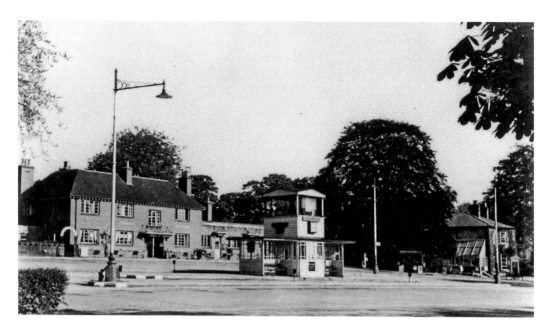

Former Coach Station, Worthy Lane

With its location conveniently close to the London Road, this was the site of the main coach station serving Winchester until 1980. It then became Flamingo Park where many package holidaymakers transferred their bags and themselves from one coach to another before setting off again on the next leg of their journey. After 1985 it was redeveloped as the Saxon Hotel, it then became the Winchester Moat House, and is now The Winchester Hotel.

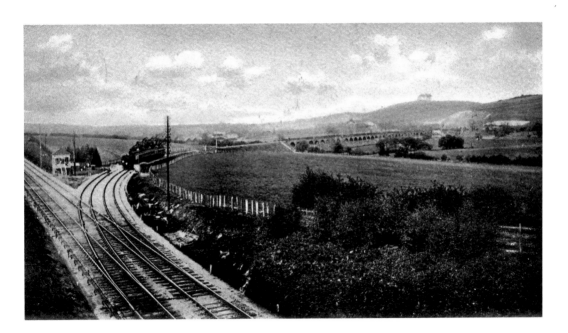

Shawford Junction

A train on the DN&S line around 1906, having just passed over the Hockley Viaduct. The bypass was built in 1938 and followed alongside the railway to the north side of St Catherine's Hill. The modern view is taken from the South Winchester park-and-ride. It is roughly at the same spot, but at a higher elevation; from it you can see the motorway slip road and hear the main railway line. The viaduct continues to be restored as a key part of the National Cycle Network Route 23.

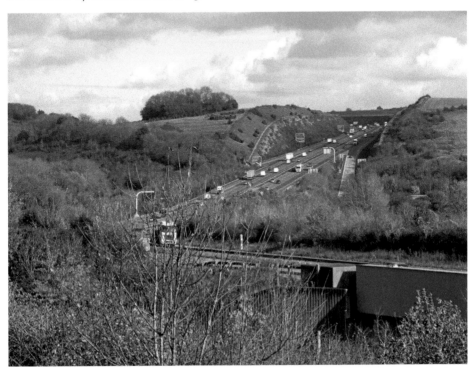

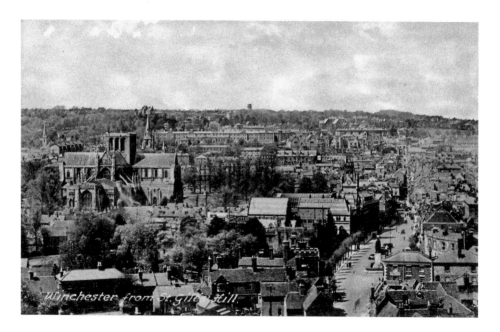

St Giles Hill

This hill is the summit of a chalk spur which falls to the east bank of the River Itchen. In the late eleventh century, St Giles Fair was held here every September. The right to hold a fair was granted to Bishop Walkelin by William Rufus, and it was to last three days. It was extended to sixteen days in the reign of Henry I and drew merchants from all over the country and Europe. It is a steep walk up wooded pathways to the viewpoint, but well worth the climb.

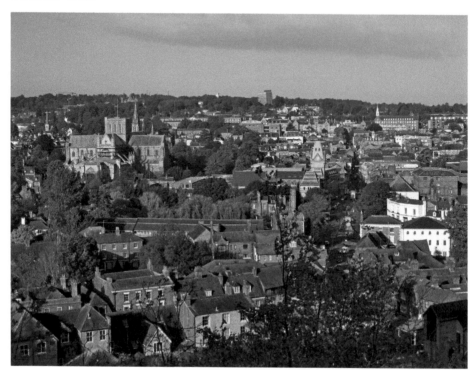

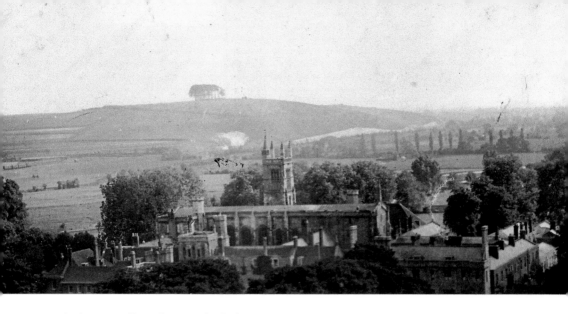

Winchester College from Cathedral Tower

This postcard was sent in 1906 and shows the vast expanse of the water meadows between the college and St Catherine's Hill. Winchester College was founded in 1382 and has the longest unbroken history of any school in England. The original buildings date from 1387 to 1400; the chapel clearly seen here was consecrated in 1394. The photograph below was taken about thirty years ago, so tree lines will have changed further.

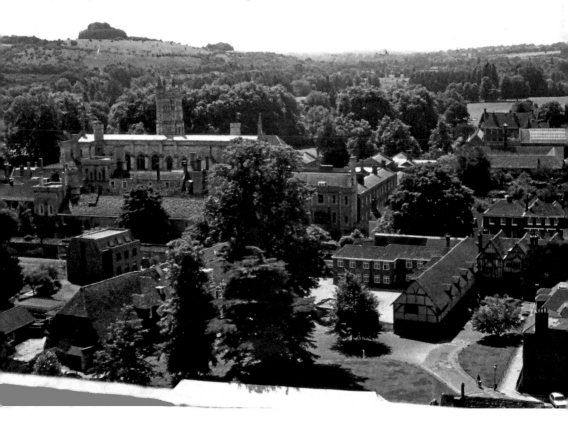

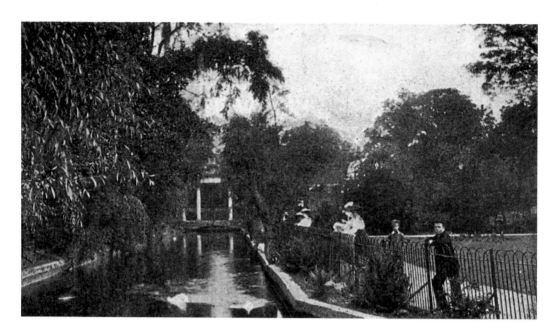

Abbey House and Gardens

On the site of the tenth-century Nunnaminster begun by Alswitha, King Alfred's Queen, these attractive gardens were opened to the public in 1890. The classical portico at the end of the stream hides the old mill, once part of the nunnery. Abbey House, built in 1751, is the official residence of the mayor.

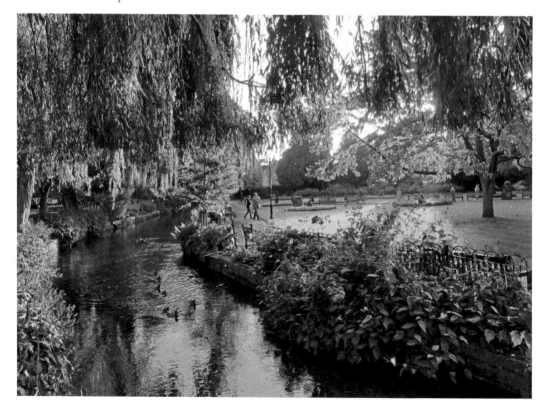

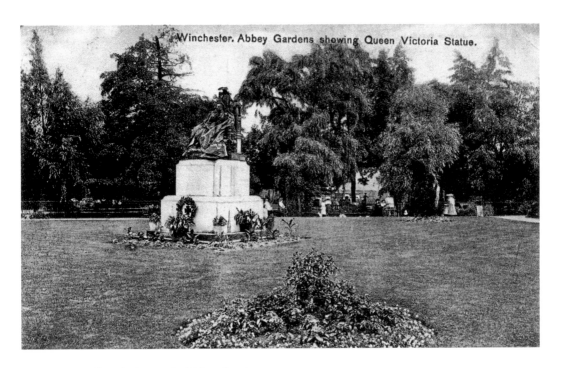

Winchester. Abbey Gardens showing Queen Victoria Statue.

Queen Victoria Statue in Abbey Gardens

The statue of Queen Victoria was moved to the gardens from the Great Hall in 1893, but when King Alfred's statue was erected in the Broadway, it was felt that he overshadowed the Queen so she returned to the Great Hall in 1910. The statue was unveiled again in 1912, and has remained there ever since.

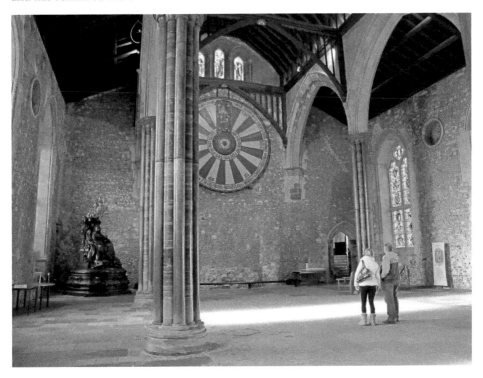

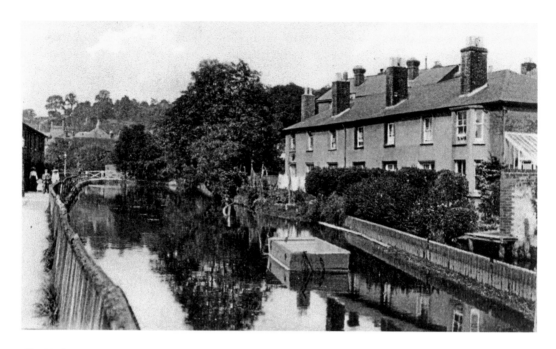

The Weirs

A walk by the river around 1900. The houses next to the smartly-dressed people were knocked down in the 1930s. The houses to the right were most likely demolished in the 1940s as they do not appear on the Ordnance Survey map of 1951. Although the wooden railings have been replaced, they still follow the same curves, and once again we see that through time, trees can tend to dominate the picture.

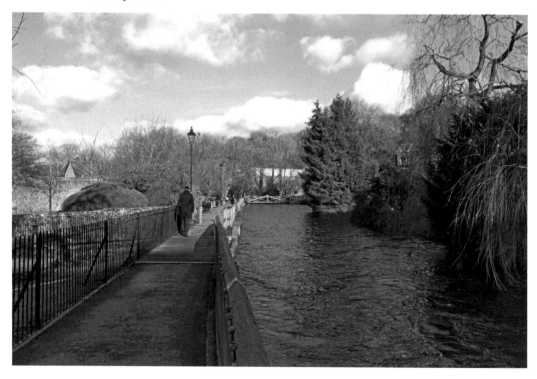

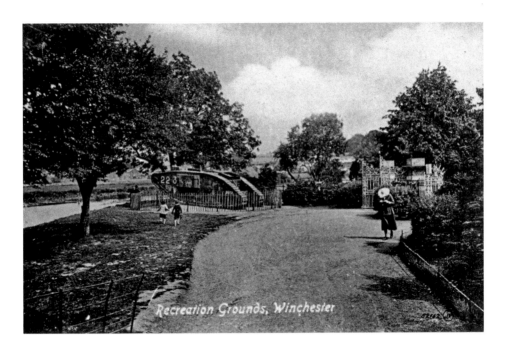

Recreation Grounds, Winchester

River Park

After its post-war presentation to the city in 1919, this tank was moved to a new spot in the recreation grounds where it was quite an attraction. It remained for several years until the start of the Second World War, when it was removed for scrap. Today the recreation grounds are a focus for fitness, with the indoor leisure centre facilities, and outdoor courts and fields encircled by paths for walking and jogging.

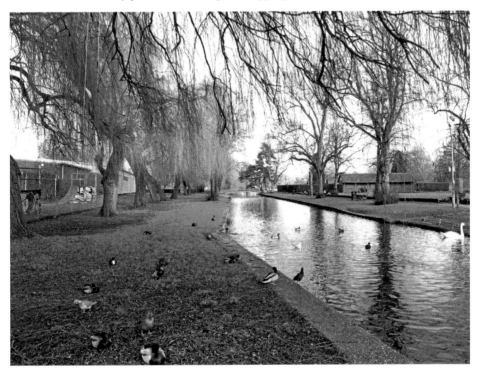

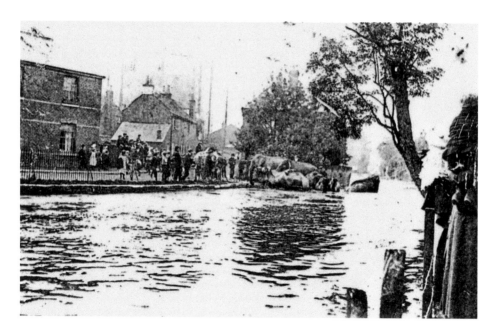

Water Lane

Elephants, presumably from a travelling show or circus, are seen here in 1905 bathing in the river and the cause of much fascination. The children on the right appear to be watching from Durngate Bridge, where there was a mill. The view from the bridge today is entirely of foliage, so the modern photograph is taken from the spot where the elephants were, looking back towards the overgrown bridge. The row of houses on the right in the present day picture is the same.

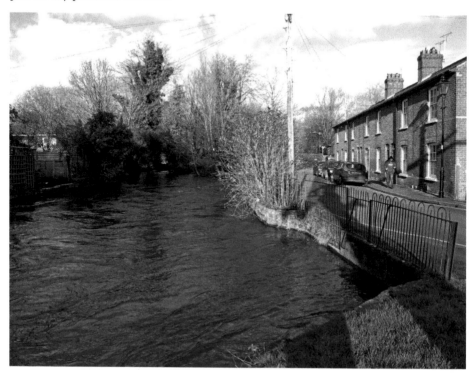

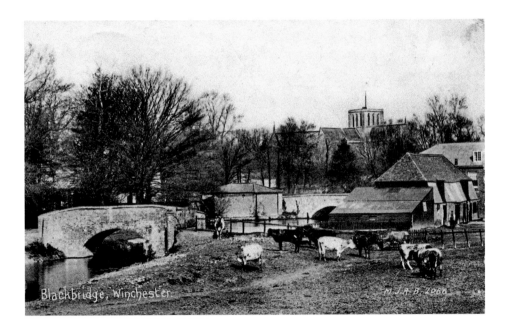

Blackbridge, Winchester.

Wharf Bridge

A very rural scene around 1900 with the cows of Wharf Dairy. At the foot of Wharf Hill is Black Bridge (the bridge to the right), a stone arch dating from 1796. This is the official head of the Itchen Navigation, a modification of the River Itchen, which was opened in 1710 to transport barges of coal and timber from Southampton to Winchester. It is impossible to get a view of the two bridges together; the modern photograph is taken from the other side of the river, the boating shed standing where the cows once grazed.

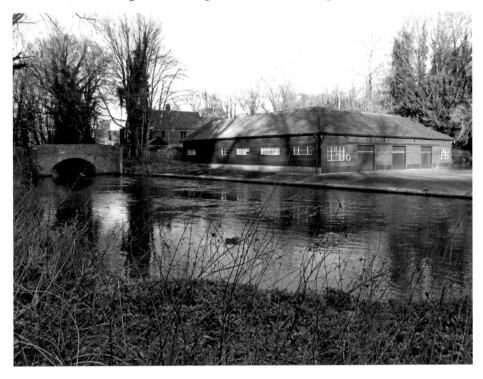

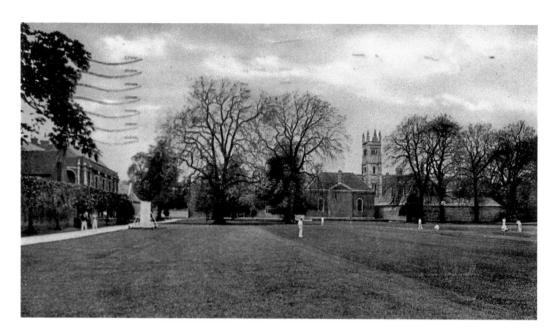

Winchester College Meads

Domum is from the Latin meaning 'homewards'; the theme in the college song is 'Dolce Domum'. It is recorded as being sung from 1768 in various locations around the college, and in 1835 in Meads, the playing fields south of the college. Winchester College football, also known as 'Our Game', is unique to the school; it is played with a soccer ball but includes a rugby-like scrum.

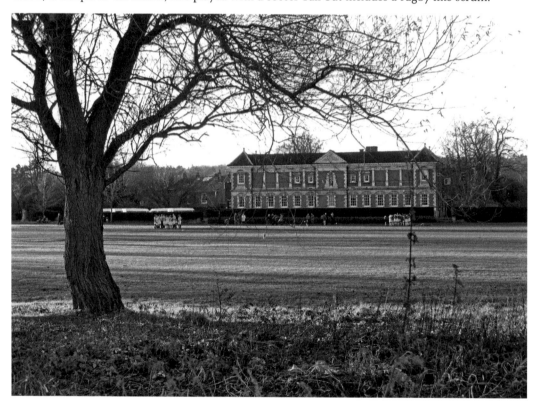

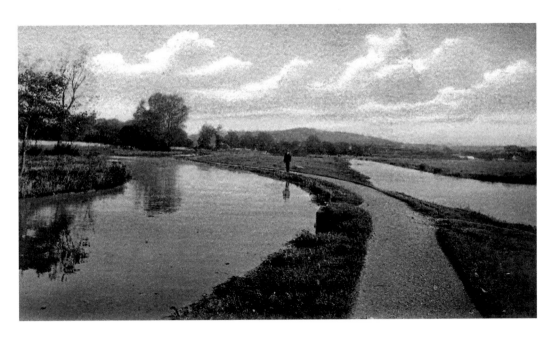

The Water Meadows

Just to the south of Winchester College, a complex of streams and channels of the Itchen Valley form the Water Meadows. They are said to be the source of inspiration for John Keats's *Ode to Autumn* when he stayed here in the summer of 1819. Whether this is the case or not, we do know that he walked here and no doubt appreciated the beautiful scenery and views across the meadows to St Catherine's Hill.

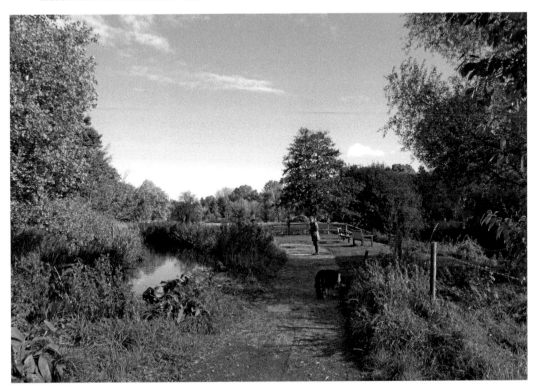

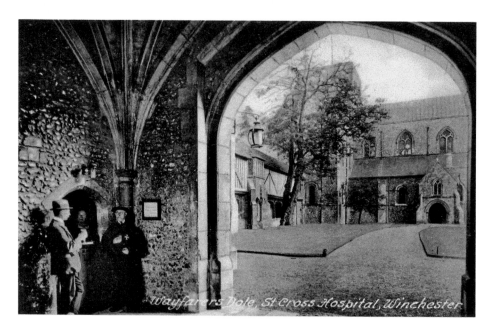

St Cross Hospital

Founded by Bishop de Blois in 1136 the hospital provided for thirteen gentlemen too frail to work, and fed another hundred at the gates each day. In 1446 the Almshouse of Noble Poverty was founded by Bishop Beaufort, for men of noble birth who had fallen on hard times. Today there are twenty-five brothers, who wear distinctive gowns. Visitors can view the church and several of the buildings, and enjoy both the Master's Gardens and in the summer months the Hundred Men's Hall tea room.

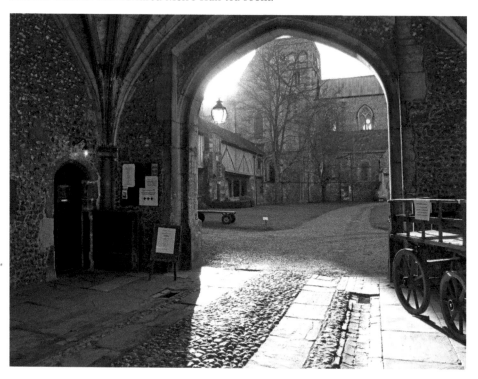

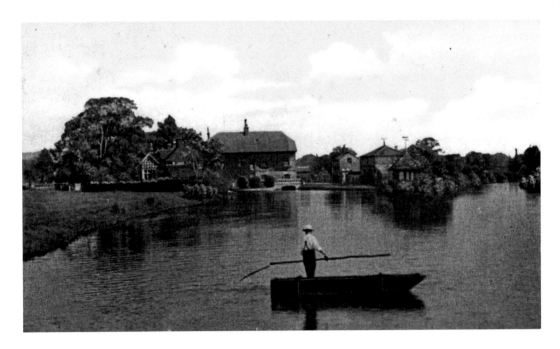

St Cross Mill

The earliest mill on this site belonged to the Hospital of St Cross; flour was ground for the brethren of the almshouses. It was rebuilt in 1843 and extended as a private house around 1900, just before this photograph was taken. The man in the punt is cutting weeds with a pole scythe. The view here is from one of the bridges along Five Bridges Road, once the main road to Twyford via the Hockley junction before the motorway was built.

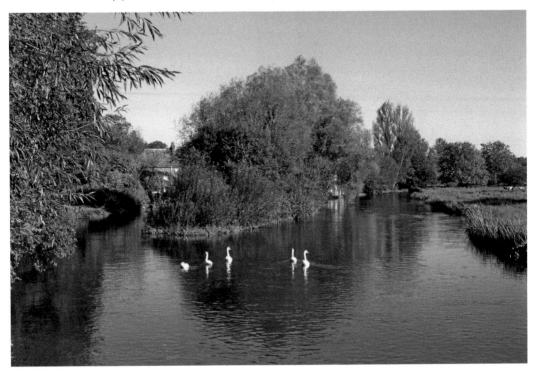

St Catherine's Hill

It is said that the beginnings of Winchester started here; indeed the excavated ditch still visible dates from the Iron Age. Until the nineteenth century a beacon stood ready to be lit in case of an invasion. The land is owned by Winchester College and the tradition of college boys using the hill as a playground goes back to the sixteenth century. Now a designated nature reserve, this flower-rich chalk grassland is managed by the Hampshire and Isle of Wight Wildlife Trust.

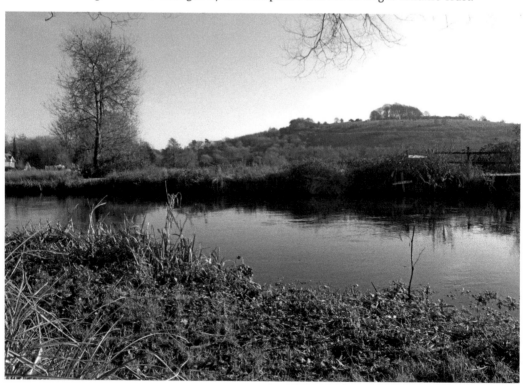

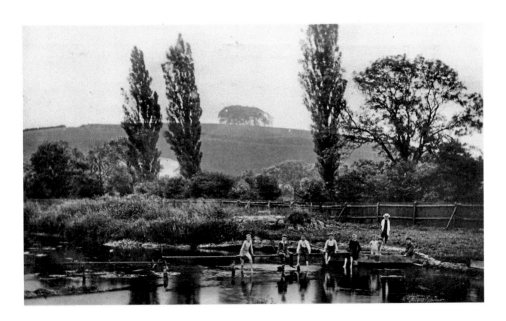

The Itchen Navigation

By 1869 the commercial traffic of barges had ceased but the towpath and waterway were enjoyed by Victorian walkers, swimmers and sailors, and Winchester College established a boat club at Wharf Bridge. The Itchen Navigation Heritage Trail Project, a five-year project which set out to improve this waterway for the benefit of walkers and wildlife, has recently been completed. This 10-mile stretch of the Itchen Way takes you from Wharf Bridge to Woodmill in Southampton.

Badger Farm

This view towards Winchester was taken in 1974, just before the development of Badger Farm and when open land still stretched between Olivers Battery and the south end of St Cross. Whiteshute Lane, just to the right of where the modern photograph was taken, forms part of the Clarendon Way, a footpath that takes you from Winchester to Salisbury.

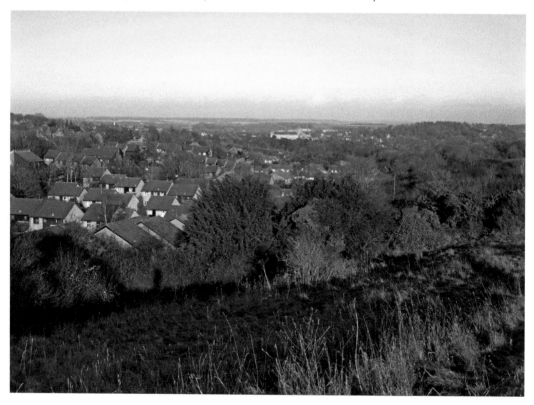

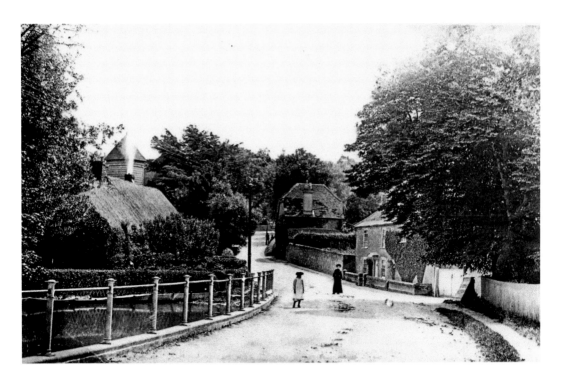

Old Village Pond, Weeke

In the mid-nineteenth century a large built-up area was beginning to grow in the districts anciently known as Fulflood and Weeke. Weeke had been part of the great priory manor of Barton. After the Second World War Weeke saw much development, with new houses also at Teg Down, and the old village centre with St Matthew's church and the pond was sadly neglected, though fortunately it survives today.

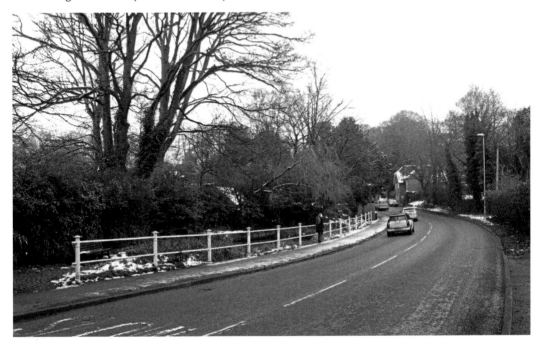

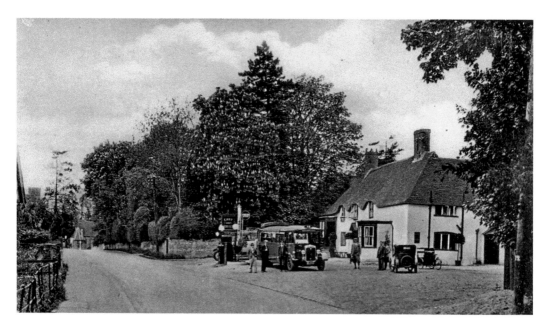

The Cart & Horses, Kings Worthy

The eighteenth-century Cart & Horses public house is seen here in around 1930, judging by the vehicles like the Austin Seven. Situated just before the turning for the main road to London, it would have been a good stopping point; there appears to be a petrol pump between the two motor coaches.

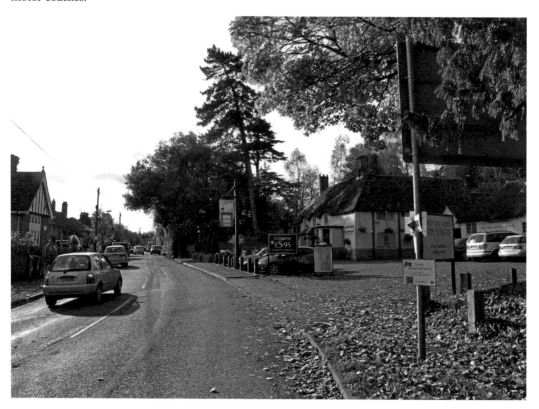

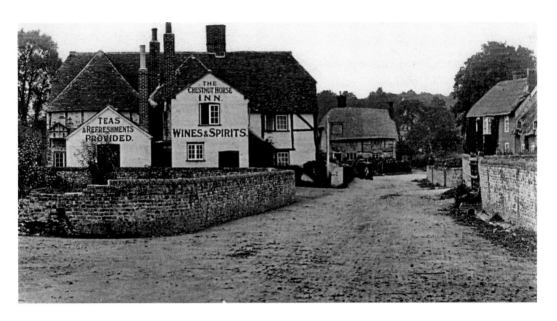

Easton Village

The sixteenth-century timber-framed Chestnut Horse Inn at Easton is pictured here sometime after 1910. As well as serving alcohol it provided teas and refreshments, and the village also had a blacksmith, two bakers, two general stores, a post office and other sundry tradesmen. It is rather quiet now, but its two public houses are still flourishing.

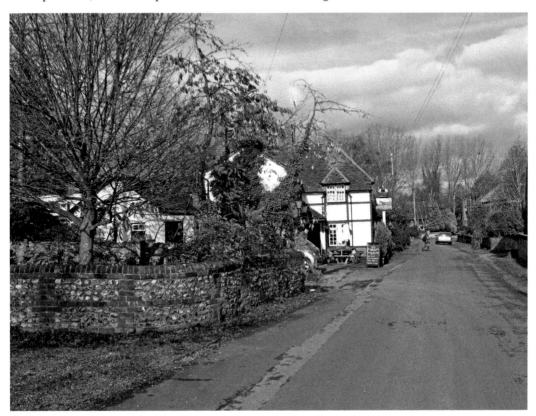

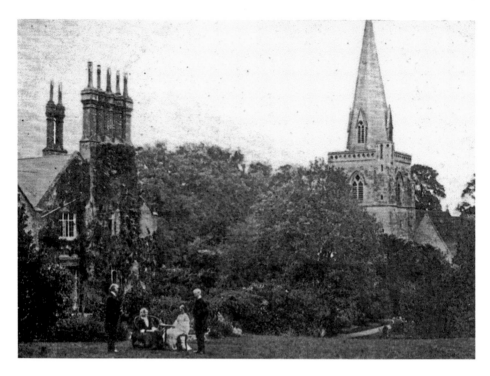

All Saints Church, Hursley

The group pictured here in 1861 in the vicarage grounds are John Keble and Mrs Keble, the author Miss Charlotte Yonge and Revd Dr Moberly. John Keble was the vicar of All Saints church from 1836 to 1866 under the patronage of Sir William Heathcote of Hursley Park, and the church was rebuilt during this time. The spire was removed in 1960 after it was declared unsafe, and around this time IBM moved into Hursley Park, purchasing the land that surrounds it a few years later.

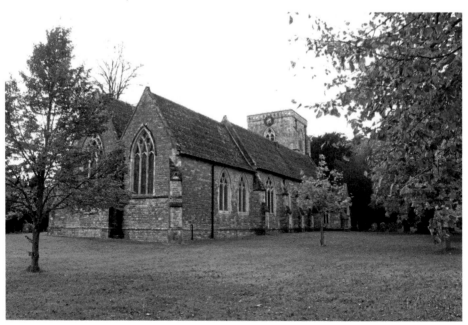

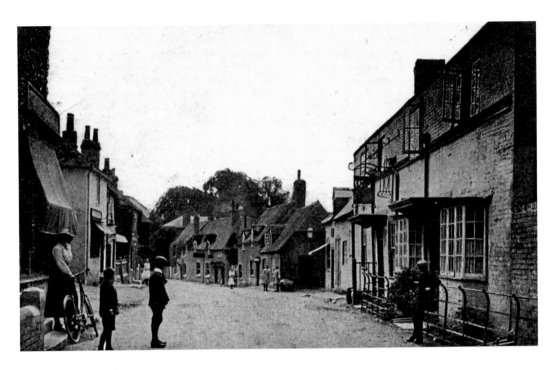

Tywford High Street

The Phoenix Inn dates back to 1690 but this building is mainly nineteenth-century; the far end of it has been demolished. The building in the middle with the lamp over the doorway is Carter's forge; the Carter family owned the forge from the early nineteenth century to 1936. Today, with its narrow pavements, the High Street isn't quite as pedestrian friendly as it was in the 1920s.

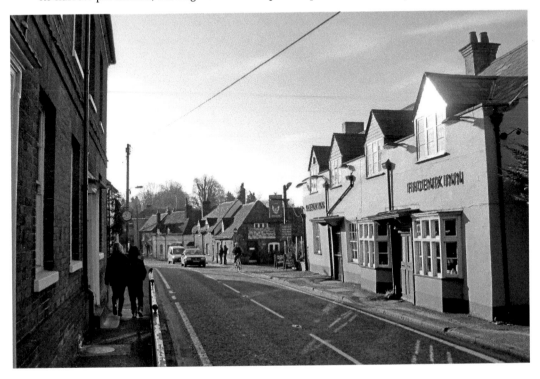

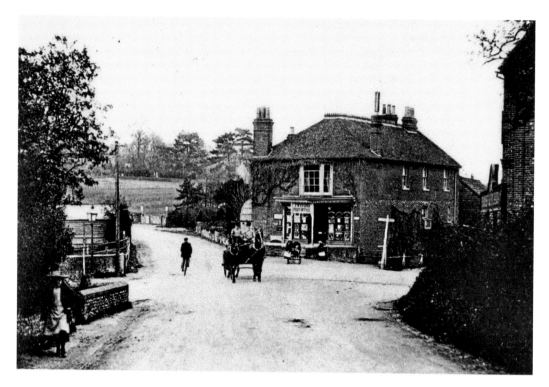

Twyford Crossroads

Twyford post office in 1892; it had originally stood on the High Street, opposite the Phoenix Inn. Further up the road in the field on the right, several buildings including the village hall now stand. The building of the Twyford Stores and post office is relatively unchanged apart from its coat of paint. The cellar, once a GPO sorting office, has been converted into the Bean Below restaurant.

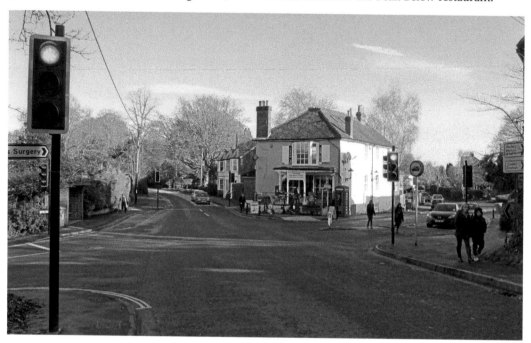

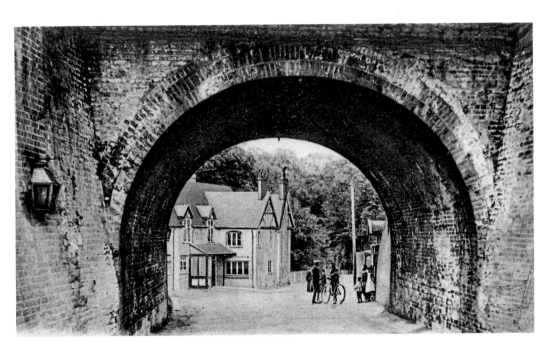

The Bridge, Shawford

Much of Shawford dates from the early twentieth century, at a time before the motor car when the railway was a valuable asset. The station here opened in 1882. The Bridge Hotel, formerly called the Bridge Inn, once kept horses for working the barges on the Itchen Navigation. Shawford is a popular spot not only for the pub and restaurant and river walks, but also the walks and views on nearby Shawford Down.

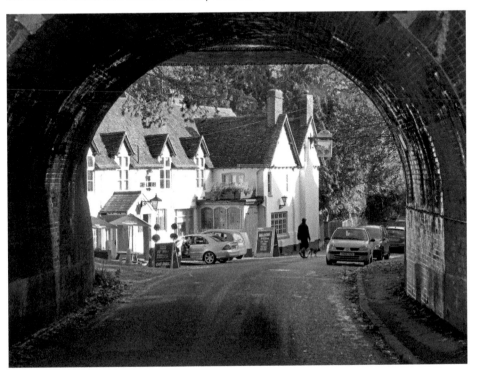

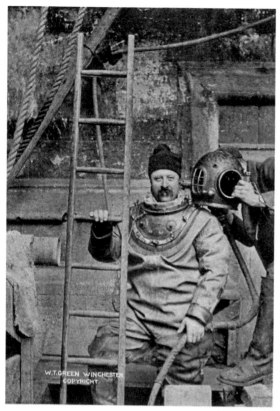

W.T. GREEN WINCHESTER
COPYRIGHT

Cathedral Crypt

In the early 1900s huge cracks appeared in the cathedral and it was in danger of collapse. The diver William Walker worked for six years in depths of 20 feet of water, filling new foundation trenches with bags of concrete. The crypt still floods during rainy months; the Anthony Gormley statue *Sound II* was designed specifically to stand in water. This is the perfect place to appreciate the work of these two men and reflect on Winchester's history.

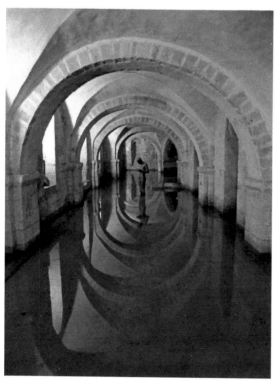